IMAGES
of America

THE ATLANTA EXPOSITION

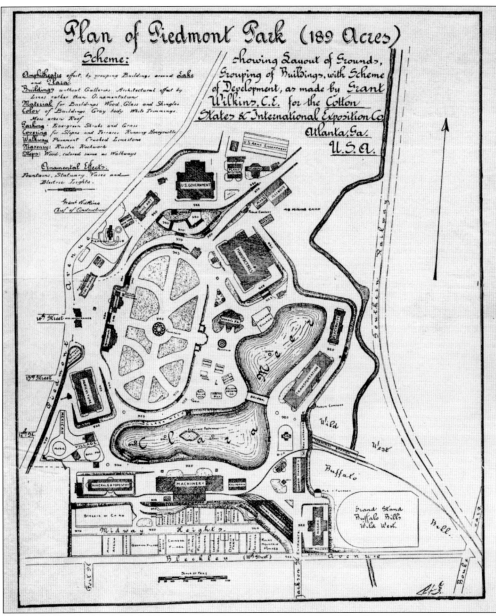

Grant Wilkins, the Atlanta Exposition chief of construction and landscape engineer, designed the layout for the fairgrounds, as seen in the above drawing. The buildings were situated around a large oval-shaped field that was in existence and was used by the Piedmont Driving Club as a horse track. The Piedmont Park that Atlantans are familiar with today is a result of Wilkins's landscape design. (Courtesy of the author.)

ON THE COVER: The bustle and joviality of a Victorian international exposition is apparent in this photograph, taken from the central plaza field looking northeast. Today the buildings in the background have been replaced by the Atlanta Botanical Garden, and the people would be standing near a volleyball court in Piedmont Park's Active Oval. (Courtesy of Georgia Archives, Vanishing Georgia Collection, Image No. 0676.)

IMAGES of America
THE ATLANTA EXPOSITION

Sharon Foster Jones

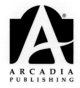

Copyright © 2010 by Sharon Foster Jones
ISBN 978-0-7385-6659-7

Published by Arcadia Publishing
Charleston SC, Chicago IL, Portsmouth NH, San Francisco CA

Printed in the United States of America

Library of Congress Control Number: 2009931592

For all general information contact Arcadia Publishing at:
Telephone 843-853-2070
Fax 843-853-0044
E-mail sales@arcadiapublishing.com
For customer service and orders:
Toll-Free 1-888-313-2665

Visit us on the Internet at www.arcadiapublishing.com

To the Piedmont Park Conservancy—
the park is as beautiful now as it was then.

CONTENTS

Acknowledgments 6

Introduction 7

1. Structures and Settings 9

2. Celebrations and Celebrities 51

3. Exhibits and Exhibitors 75

4. Relics and Ruins 111

Bibliography 127

Acknowledgments

I would like to acknowledge one person—my husband, Craig T. Jones—for his contributions to this book. Much of the material in this collection has been presented by him to me as gifts. Antique books, newspapers, and medals have made it into anniversary and birthday presents, and he has occasionally tucked a stereoview photograph into a Christmas stocking. He sure knows the way to this girl's heart! With his history degree from Brown University, Craig has guided my amateur Atlanta historic research and taught me to love discovering the past. He has maintained a healthy curiosity about my research without ever crossing the precarious line of interfering with my writing. For all these things and more, thank you, boyfriend.

Unless otherwise noted, all images in this book appear courtesy of the author.

INTRODUCTION

From September 18 until December 31, 1895, Atlanta hosted the Cotton States and International Exposition, and Henry Grady's New South garnered worldwide attention. This exposition proved that the South was ready to face a post–Civil War existence with industrial, agricultural, and intellectual strength. More than 1 million people thronged through the 189-acre fairgrounds over the course of 100 days and were amazed at how far the state of Georgia had come in the 30 years since the war. Exhibits displayed the cotton industry, of course, but they also demonstrated food production, transportation, education, electricity, and art. It was a kaleidoscope of humanity and human accomplishments.

Architects and engineers designed the fairgrounds to delight and awe the fairgoers. Chain-gang labor moved countless yard of earth to form an amphitheater-shaped setting for the giant Romanesque structures that housed the exhibits. Hundreds of workers enlarged the small pond existing on the grounds to form an 11-acre lake where an electric fountain shot water into the sky in rainbow colors. Women and African Americans claimed their own stately buildings to showcase their newly realized skills. All the buildings were ablaze with cutting-edge electric lights. Photographers and artists captured the essence of the exposition with panoramic views of the massive buildings encircling the waters of Lake Clara Meer.

Celebrities of all kinds appeared at the fair. Pres. Grover Cleveland was a fan of the exposition fever that the world was experiencing in the late 1800s, and he visited the fair in October, speaking at the President's Day ceremony. Pres. William McKinley appeared at the exposition when he was still governor of Ohio. Advocating racial harmony, Booker T. Washington spoke at the Opening Day ceremonies in his speech known today as the "Atlanta Compromise." The Liberty Bell traveled to the exposition, and thousands of children stood in line for the chance to touch it. Civil War veterans marched through the grounds on Blue and Gray Day with famous generals addressing the cheering crowds. In an outdoor arena, Buffalo Bill's Wild West Show entertained with guns and horses and Native Americans in full warrior attire.

Inside the buildings, exhibits offered an encyclopedic variety of knowledge and entertainment to people from all circumstances of life. Photographs from the exposition show buildings crammed with statues and machines and wildlife. People sought the pleasure grounds of Midway Heights, a vanity fair with a circus-like atmosphere of exotic animals and people. These late-Victorian attendees were naive; most had never encountered foreign cultures and were fascinated by the fake villages upon the Midway that showed Mexico, China, Japan, and Egypt.

In the late-Victorian world, expositions were fairs that not only promoted a particular city, but also promoted the advancement of civilization as a whole. Expositions were popular all over the world. The end of the 19th century saw many of them, such as the 1893 World's Columbian Exposition in Chicago, the 1900 Exposition Universelle in Paris, the 1901 Pan-American Exposition in Buffalo, and the 1904 Louisiana Purchase Exposition in St. Louis.

The expositions at that time reflected the paradoxical state of race relations and civil rights existing in America. Money and white supremacy were driving forces behind the Victorian expositions, and Atlanta was not exempt. While Atlanta bragged of having the first "Negro Building" in an exposition, the truth is they were forced to do so by the U.S. Congress in order to receive federal funds for the exposition. Without federal backing, the other nations of the world would not have participated officially, and the exposition would have been nothing but a mere local carnival. Despite the outward gestures of racial harmony, racism and segregation were in full force on the fairgrounds. Only the Negro Building served food to people of color. The very existence of a Negro Building was racist and patronizing. Upon the Midway, the Old Plantation attraction glorified the days of American slavery. The foreign and Native American "villages" that were on display throughout the grounds further supported the white supremacy ideas of the exposition promoters and much of the world. Village people were displayed in hilarious stereotypical clothing and settings, and such ideas were supported by the current science as anthropological.

It had only been a few decades since African Americans were considered chattel by many people in the nation, North and South. Travel was difficult, and foreign culture was unknown to the majority of America. The race-relation steps that the exposition took most likely did contribute to the advancement of equal human rights. They were baby steps, albeit forced, but they were steps in the right direction.

Atlanta held the exposition for a number of reasons. The Cotton States' progress since the war was a chief motive, and the exposition promoters wanted to cement that by illustrating to the country that America needed the South to survive in an industrial world. The Southern states could contribute to the national economy by providing goods and services along with the rest of the country. They could export through Southern ports. Central and South American countries like Mexico, Costa Rica, and Venezuela were invited, escorted, and pampered at the exposition, for these were the places that could import Southern goods. To exposition leaders and to Booker T. Washington, the question of the role of the black man was answered by promoting African Americans as a great labor force in the South. Patriotism and national unity were strong forces that gave the cold economic goals of the exposition some heart. Every building throughout the fairgrounds was adorned with the American flag. On a simpler level, the exposition stimulated the local sagging economy with thousands of attendees utilizing local transportation, lodging, and food services.

Worldwide, the goals of expositions were more general in nature. Commercial advertisements and knowledge of products promoted world economic growth. The expositions of the period educated millions of people, many of whom would never have had such an opportunity without an exposition forum. These were the early days of the modern world; people were without the means to communicate advancements globally in an effective manner. The Victorian expositions gave a sense of order in a rapidly changing world. They showed the world where it was going, and they were wildly successful. The optimism of the 19th- and early-20th-century expositions was palpable.

Today Atlanta's most popular park, Piedmont Park, is located on the old exposition grounds. Thousands of park visitors stroll past the crumbling ruins of the fair with little thought to the origins of the park's ancient stone planters. The shores of Lake Clara Meer are now pastoral with no remnants of exposition construction. Midway Heights is now pristine rolling fields. The central Plaza, which was once surrounded by the main buildings of the exposition, now plays host to baseball games, volleyball tournaments, and a well-trod running path for today's Atlantans. The great fair of 1895 is simply called "The Atlanta Exposition" by historians, but its effects upon Atlanta are as complex and permanent as its physical imprint that remains upon the land.

One

STRUCTURES AND SETTINGS

An artist's rendering from a bird's-eye view illustrates the layout of the Atlanta Exposition. Over the course of a year, the exposition directors created a setting to impress a savvy international audience; they hired renowned architects and literally moved the earth. Compared to other Victorian world fairs, the Atlanta Exposition grounds were small but exquisite—the perfect background for a fair that captured the world's attention for 100 days.

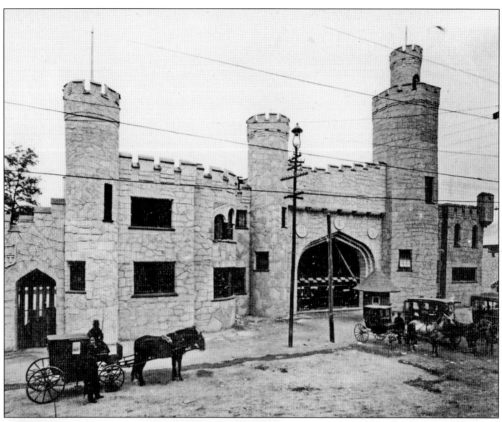

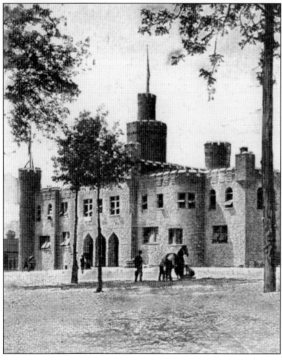

For most visitors, the first building encountered at the exposition was the Administration Building, seen here. Made of tinted staff, a temporary concoction of plaster and jute, this building appeared to be made of stone. The majority of the Atlanta Exposition's structures were constructed of Georgia pine and not staff, thereby avoiding the white-city look that many expositions of the time had. The Administration Building had the official carriage entrance and contained ticket booths and turnstiles. Inside the building were the exposition offices, the newspaper headquarters, and a bank—the Atlanta Trust and Banking Company. The Board of Women's Directors set up an office in the building but moved to the neighboring Fire Building because they believed their presence was unwanted by the men in the Administration Building.

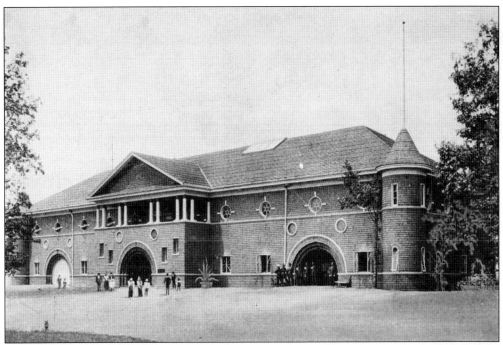

To the north of the Administration Building was the Fire Building. A fire alarm system was set up near the exhibits on the fairgrounds so that firefighters could be dispatched quickly should the need arise. The building contained exhibits of ancient fire-fighting methods, and firefighters frequently demonstrated the latest hoses and paraphernalia outside the building.

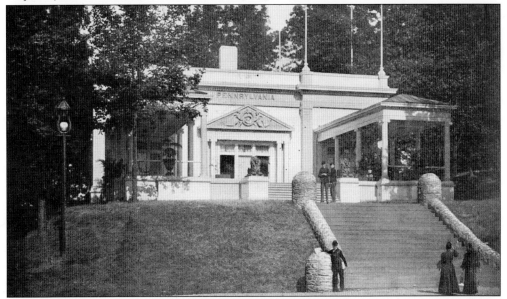

Continuing north in a clockwise direction from the Fire Building and adjoining the Piedmont Driving Club grounds was the Pennsylvania State Building. It was considered to be the best and most frequented state building at the fair because it housed the Liberty Bell on its visit to the Atlanta Exposition. The Pennsylvanians gave the building to the Piedmont Driving Club after the exposition.

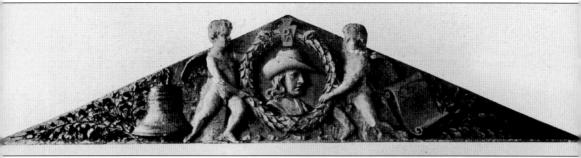

Over the main entrance to the Pennsylvania State Building was a pediment carved with the images of William Penn, the Liberty Bell, and other symbolic emblems of the state. Over the pediment was the word "Pennsylvania," outlined in electric lights. An oil painting of William Penn was on display inside the building as well.

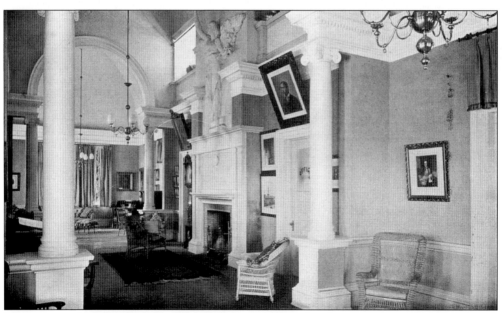

The interior of the Pennsylvania State Building provided a headquarters and place of rest for the Pennsylvanian fairgoers. Copies of the latest Pennsylvania newspapers, railroad guides, writing materials, and a post office were available for the state's weary travelers. The main reception room is seen here. Over the fireplace is a carved figure called *Victory*. The prominent portrait over the office door was of Pennsylvania governor Daniel H. Hastings.

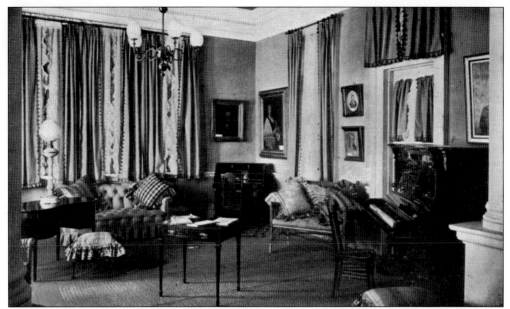

Inside the Pennsylvania State Building and to the side of the main hall was a ladies' parlor for the women of Pennsylvania's comfort at the fair. There was an adjoining restroom, finished in marble. The parlor, as well as the rest of the building, was decorated in a Colonial style with a multitude of antiques and fine fabrics. Electric lights illuminated the entire building, inside and out.

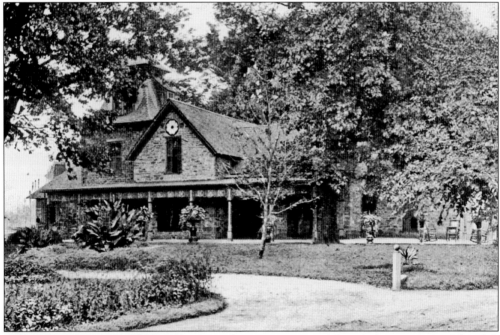

The Piedmont Driving Club House is seen here as it appeared during the exposition. The club members owned a private corporation—the Piedmont Exposition Company—that leased the fairgrounds to the developers of the Atlanta Exposition. This photograph appeared in *Harper's Weekly* the week of October 5, 1895. Once a farmhouse, the building has survived since 1868 and continues to house the club today.

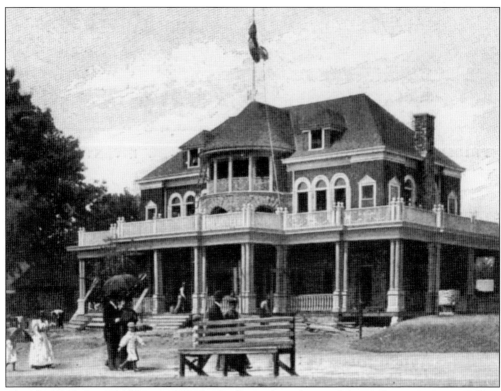

The New York State Building, seen here, was located northeast of the Piedmont Driving Club on the club's grounds. Inside the building, travelers from New York could find elegant surroundings for their use. The building contained a reception hall, a banquet hall, women's and men's parlors, and offices. After the exposition, the state donated the building to the club.

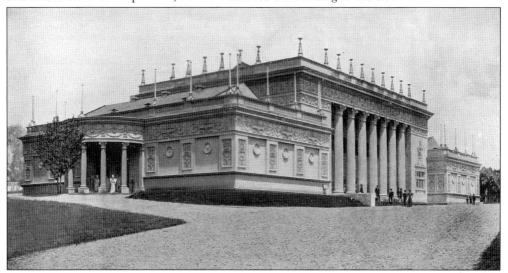

Considered one of the finest buildings on the fairgrounds, the Fine Arts Building was northeast of the New York State Building. It was designed by Atlanta architect Walter T. Downing in a classic style and covered with white staff. The building was located on the highest site at the park and contained 21,000 square feet. There were 30,000 square feet of wall space for hanging art.

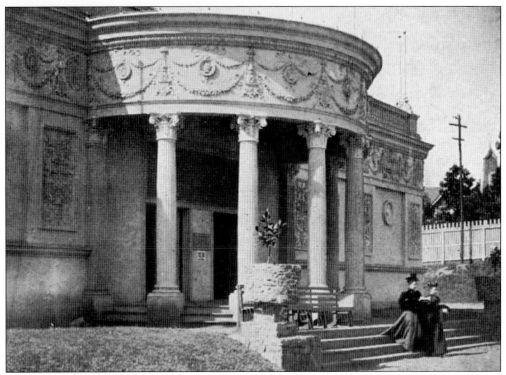

Two ladies emerge from one of the two gallery wings of the Fine Arts Building. The doorway of each gallery was covered with a semicircular portico. Each wing was 100 feet long, 50 feet wide, and 20 feet high. The urn-shaped planter exemplifies many of the stone ruins still existing on the grounds today.

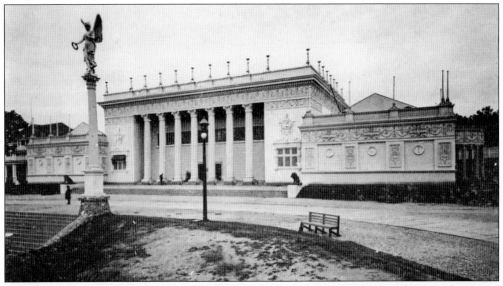

Continuing eastward, the Fine Arts Building is seen from the incline leading down to the Grand Plaza, which is the central open field that is known today as the Active Oval. The *Atlanta Journal* often referred to the entire area on the north end of the fairgrounds as Art Palace Hill. At night, the giant white art gallery shone like a beacon to the surrounding countryside.

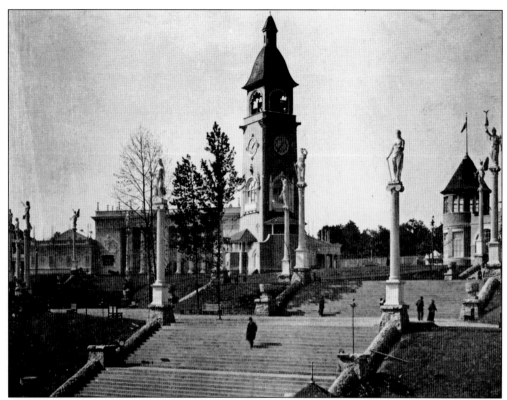

In front of the Fine Arts Building was the Chimes Tower. There were 13 bells played by Mary Butt Griffith of Atlanta from a parlor located about halfway up the tower. She was the first female chimes ringer in America and played at the Columbian Exposition in Chicago in 1893. The tower was 136 feet high. The first song played at the Atlanta Exposition was "Nearer my God to Thee."

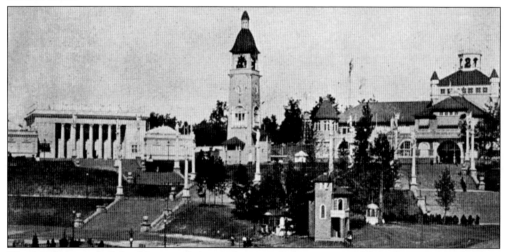

The northern end of the fairgrounds is seen here, including a view of the split staircases leading to the buildings there. Hundreds of workers, most of whom were Fulton County convicts, terraced the steep hill for the exposition and flattened areas where the buildings were erected shortly thereafter. Today much of the hill is part of the Atlanta Botanical Garden grounds.

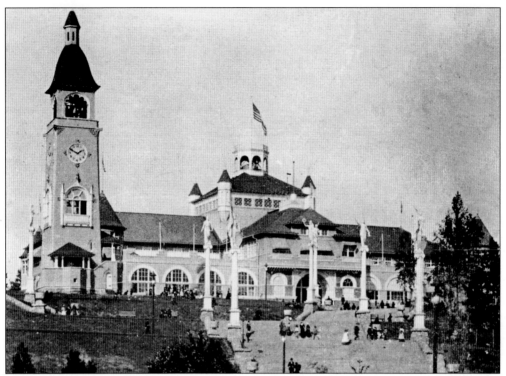

East of the Chimes Tower loomed the large U.S. Government Building. It was imperative to the success of the Atlanta Exposition that the federal government partake in the fair to give it credibility to the world. The government spent $50,000 on the building—about the cost of 10 Atlanta mansions in 1895.

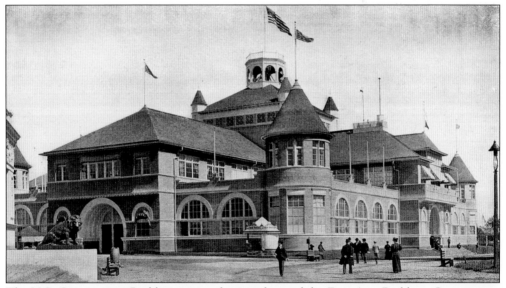

The U.S. Government Building is seen from in front of the Fine Arts Building. Government architect Charles S. Kemper designed the building in an unpretentious style, but the building impressed the crowds with its large size and airiness. Overall, with an annex, the federal government structures contained 58,000 square feet of exhibit space.

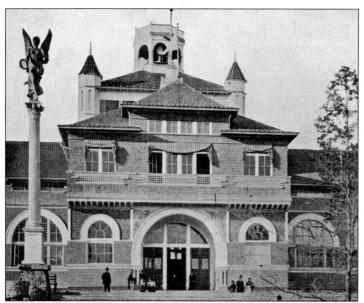

Upon closer inspection, the U.S. Government Building's shingled facade is apparent. The building occupied the highest elevation at the fairgrounds, and the U.S. government spent more than any other entity on any other building at the exposition. The building's commanding position and expense were evidence of the importance of the Atlanta Exposition to the national government and thus to the world.

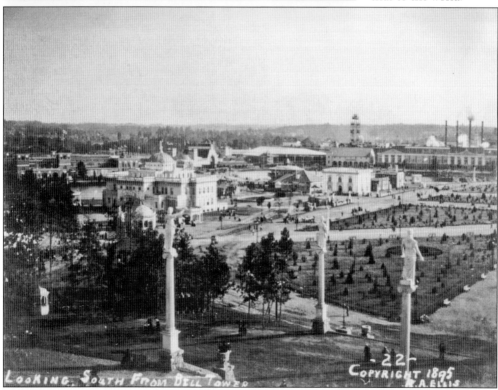

The Atlanta Exposition grounds were meant to strike awe in the average visitor. Including pedestals, the statues in the foreground were approximately 25 feet high and were designed especially for the exposition. The statuary placed throughout the grounds were named *Soldier, Sailor, Comedy, Painting, Eloquence, Dance, Commerce, Progress, Sculpture, America, Law, Art, Justice, Mercy, Scripture, Fisheries, Mines, Lion, Spring, Summer, Autumn, Winter, Peace,* and *War.* (Courtesy of the Library of Congress, LC-USZ62-70208.)

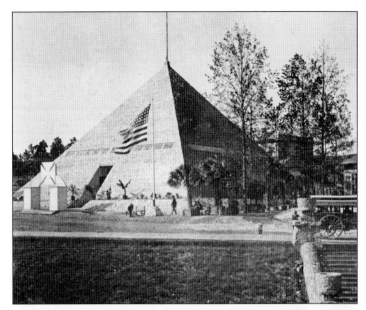

Named the Plant System Building, this pyramid-shaped structure was built by private exhibitor H. B. Plant, a Southern developer whose companies included railroad and steamship lines. The exterior was made of phosphate from Georgia and Florida, and the building was 100 feet square at the base and 60 feet high. Inside the building were displays from areas that were developed by the Plant businesses, particularly from Florida.

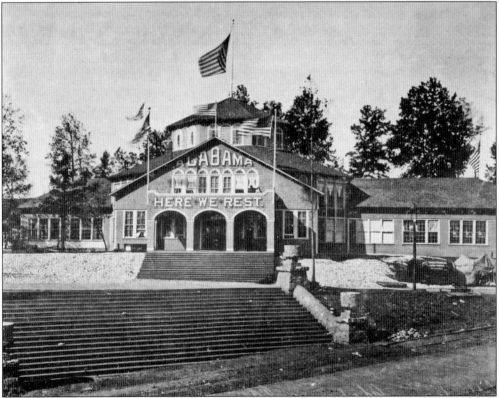

The Alabama State Building was one of seven buildings constructed by individual states. It was located on the Art Palace Hill, east of the U.S. Government Building. The state's motto of "Here we rest" was displayed across the front. Products and natural resources from Alabama were exhibited inside. The state carved a simulated coal mine into the side of the hill adjoining the building to show the inner workings of a mine.

Rounding the eastern corner of the northern end of the fairgrounds was the Confederate Relics Hall, seen here during its construction. Originally exposition directors were against this exhibit because it reminded visitors of the South's unpatriotic secession from the Union. They eventually realized the importance of Confederate history and acquiesced. Ironically, federal soldiers were encamped on the fairgrounds in tents nearby, and they guarded the relics during the fair.

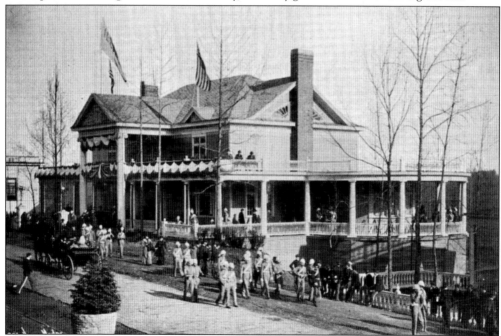

The Illinois State Building was adjacent to the Confederate Relics Hall. It provided a headquarters and resting place for the citizens of Illinois when they visited the fair and contained no exhibits. Over 100 armchairs were available for Illinois citizens. This state's leaders recognized the importance of Atlanta's exposition because Illinois had hosted a larger one in Chicago two years earlier.

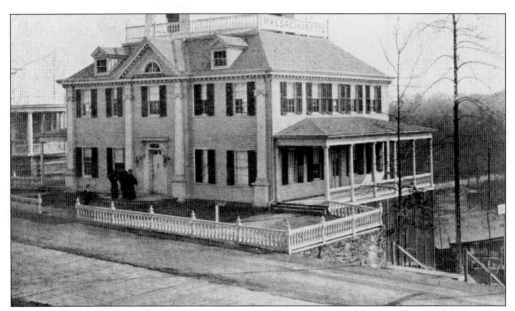

Massachusetts constructed its building beside the Illinois State Building on the northeast corner of the exposition grounds. It was designed to be an exact replica of famous American poet Henry Wadsworth Longfellow's house in Cambridge, Massachusetts. A school display took up most of the interior of the building, and the state provided the building to its citizens for their comfort.

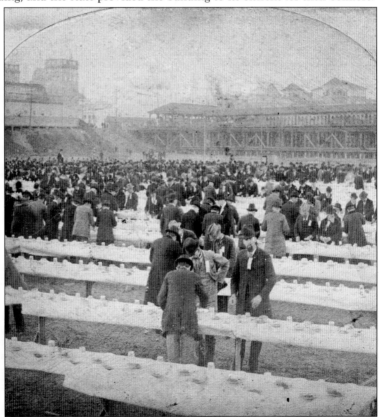

Behind and south of the Massachusetts State Building was a massive barbecue dining facility, including numerous tables with standing room only. In addition to everyday fairgoers, the barbecue was large enough to feed the military troops who paraded throughout the grounds during the exposition. The most popular dish was Brunswick stew.

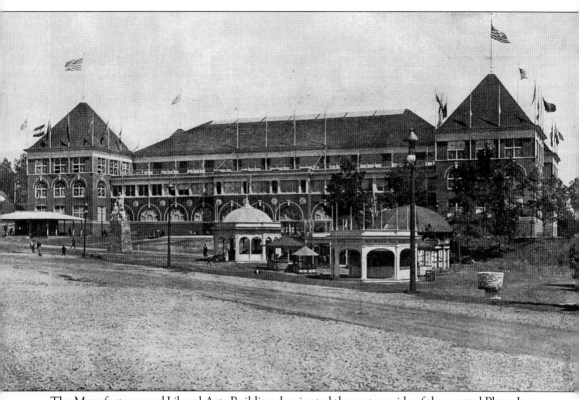

The Manufactures and Liberal Arts Building dominated the eastern side of the central Plaza. It was known as the Main Building because of its immense size and incredible volume of exhibits. With 103,000 square feet of floor space, the building was the largest structure on the fairgrounds. The end towers were three stories tall. Everything for human existence, comfort, and luxury was exhibited in the Main Building by American and European manufacturers. In front of the Manufactures and Liberal Arts Building to the far left in the above photograph was the East Indian Pavilion. It contained exhibits of manufactured products from the Orient and served tea. Candies, snacks, and souvenirs were commonly sold from individual booths around the fairgrounds. As seen here, beef tea was apparently in high demand, as an entire booth was dedicated to serving it. Today the area where the Main Building was located contains Piedmont Park's tennis courts.

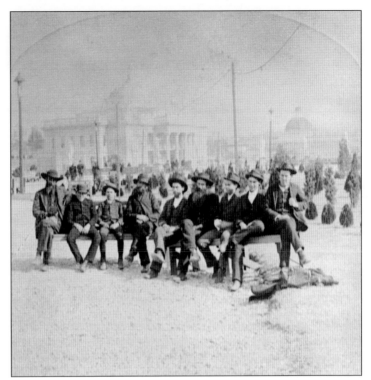

Seven men and two boys rest on a bench in front of the Manufactures and Liberal Arts Building. The white building in the background is the Woman's Building. Exposition officials bragged they could seat 30,000 people at one time in the park if necessary. (Courtesy of Georgia Archives, Vanishing Georgia Collection, Image No. 0664.)

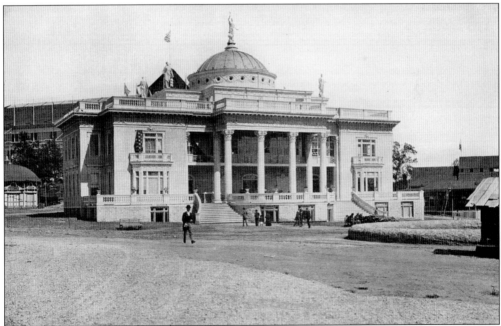

South of the Main Building between the Plaza and the lake was the Woman's Building. A female architect, Elise Mercur of Pittsburg, designed this structure. The women of Pennsylvania donated the five statues on the roof, which were also designed by Mercur, to their sisters of Georgia. The shack in the right foreground was a food vendor called the Creole Kitchen that was run by representatives from the Woman's Building.

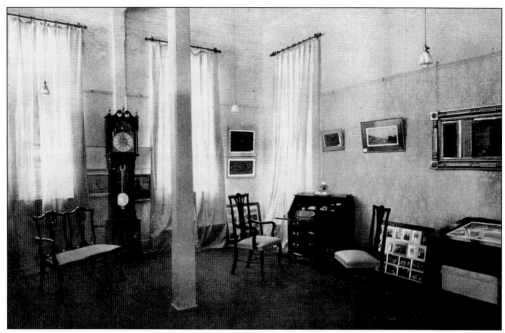

Some American cities and states had their own rooms in the Woman's Building. These rooms served as comfort stations to the travelers of the city or state, and they exhibited the women's accomplishments in art, literature, science, and decor. The Connecticut Room is shown here. Velvet carpet in electric blue with a border of pink and cream roses adorned the floor. The silk wallpaper and furniture upholstery were pale blue.

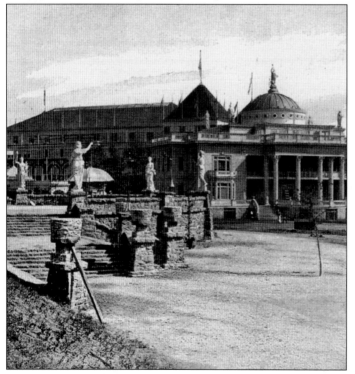

The Woman's Building was covered with white staff. Its dimensions were 128-by-150 feet, and the central dome rose 90 feet above the floor inside. In the basement was an emergency hospital staffed with Grady Hospital physicians who treated ill fair attendees free of charge. This photograph from the October 19, 1895, edition of *Harper's Weekly* shows the stone parapet that still exists today west of the building.

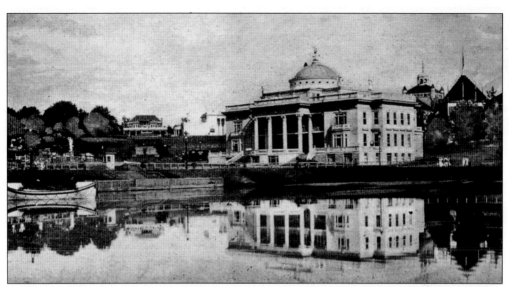

This view of the Woman's Building from the south is from the December 5, 1895, *Leslie's Weekly*. Women visitors to the exposition met in the large central hall of the Woman's Building for a daily Women's Congress that consisted of educational speeches. One speaker, a Mrs. Antrim of Philadelphia, advised in her speech, called "Physical Culture," that women never drink liquid with meals or bathe after a full meal.

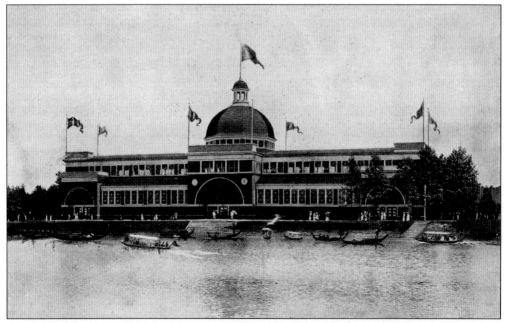

Across the lake near today's Park Drive entrance to Piedmont Park was the Electricity Building. Its interior had a floor area of 21,000 square feet. The central dome was 60 feet in diameter and rose 100 feet above the floor. Inside were exhibits pertaining to advancements in electricity. At night, the Electricity Building was the most well-lighted building on the grounds.

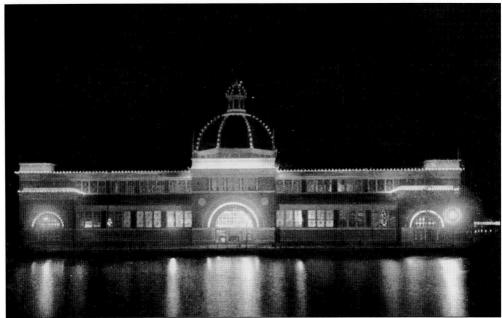

Night skies were deep black at Piedmont Park in the days before an electrified Midtown Atlanta pressed against its borders. The well-illuminated Electricity Building is shown here on the shores of Lake Clara Meer. In November, the exposition directors reduced the price of admission at night from 50¢ to 25¢ to boost evening attendance.

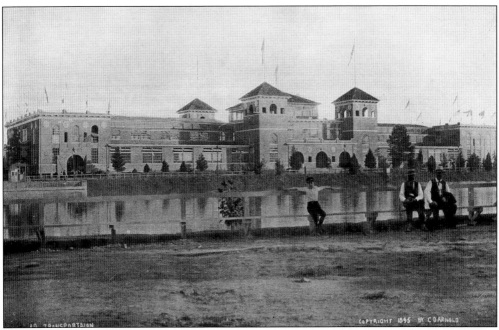

Two men and a boy rest by the western shores of Lake Clara Meer with the Transportation Building in the background. The building was long—433 feet. It contained exhibits such as railroad relics, wagons, bicycles, and streetcars. The Transportation and the Electricity Buildings were adjacent, and between them was a restaurant called Union Palace that benefited the Industrial Union.

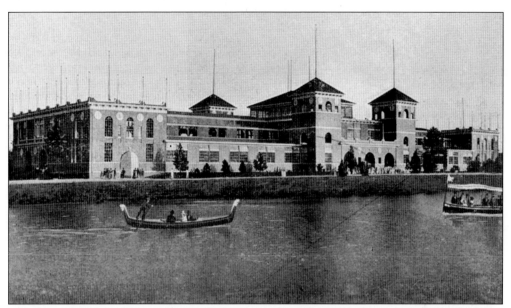

The cost to build the Transportation Building was $16,000, which was a small amount relative to the size of the building. Costs were reduced because the structure was built on the foundation of an old building from the 1887 Piedmont Exposition. The boat on the right side of the image was electric.

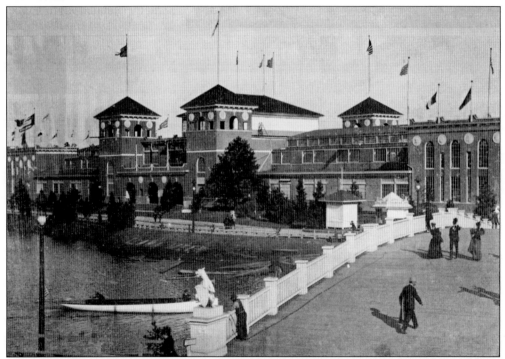

The Piedmont Exposition of 1887, a dress rehearsal for the Atlanta Exposition, created a small pond on the grounds. It was enlarged and named Lake Clara Meer for the 1895 exposition, and included two connected lagoons situated at right angles to each other. At the junction of the lagoons, a bridge connected the north and south areas of the exposition fairgrounds, as seen here.

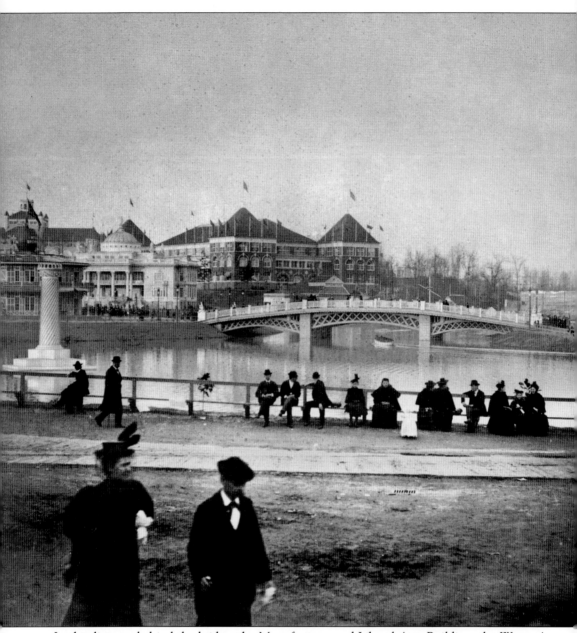

In the distance behind the bridge, the Manufactures and Liberal Arts Building, the Woman's Building, and the round Atlanta Brewing and Ice Company Building can be seen in the fog. Viewed from the south, the bridge over Lake Clara Meer, referred to by fair visitors as the "humpback bridge," created a graceful sight for those resting at the fair. The entire lake was wreathed in benches that did double duty as safety barriers from the steep banks that led down to the water. Atlanta Exposition directors addressed the practical issues of human needs at the fair to the best of their 19th-century abilities. Exposition president Charles Collier ordered drinking fountains put on the grounds, each of which consisted of a wooden barrel with 50 spouts and 50 dippers. Other human-needs issues were addressed in buildings throughout the grounds labeled "public comfort"—the details remain in obscurity, but they were probably some sort of mass outhouses.

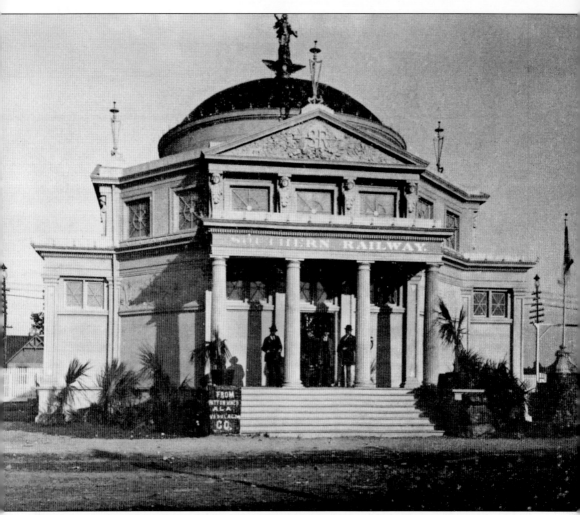

The octagon-shaped Southern Railway Building was located in the southeastern portion of the fairgrounds between the lake and the area known today as the Meadow. Bas-relief carvings of old stage coaches and current train systems adorned the building. Pyramids of coal were piled outside adjacent to the structure, and the railroad company set up pieces of track for educational purposes, showing different periods of railroad history. On the interior, this private exhibitor, Southern Railway, displayed the resources of the eight states through which its lines traveled. Exhibits of minerals and gems in cases were located on one side, and fruits of the South were on the other side. Much of the Atlanta Exposition's success was because of the efforts of the railroad companies, who advertised the exposition by distributing flyers to their passengers and displaying lithographs of the exposition on their trains—some at the railroads' own expense.

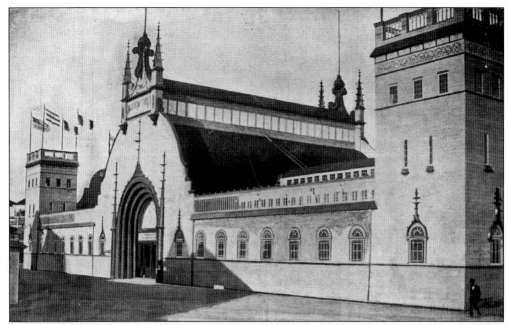

South of the Southern Railway Building was the orange-colored Georgia Manufacturers Building. On October 11, 1895, the *Atlanta Journal* stated that this building's exhibits demonstrated that "a great people have been awake and working since the days when poverty followed bloodshed."

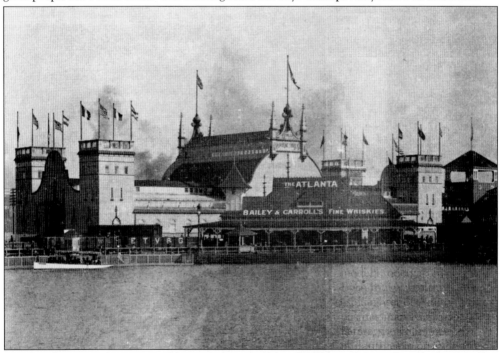

The Georgia Manufacturers Building can be seen behind Bailey and Carroll's, which was a bar. Inside the Georgia Manufacturers Building there were an operating, full-sized sawmill and a complete house built of Georgia yellow pine. Cotton grew on the Plaza, and it was picked, ginned, carded, spun, woven, and sewn into clothes in one day in this building.

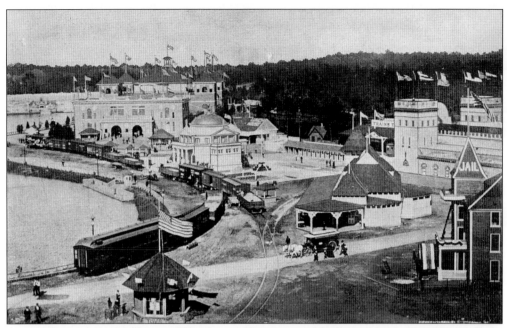

An aerial view from the Phoenix Wheel, a smaller version of the Ferris wheel, shows the southeast portion of the fairgrounds. To the right was a building called the Model Jail, which exhibited the best conditions for incarceration. There was a model school on the fairgrounds as well. The train shown near the lake was the Scenic Railway, an amusement ride and not actual transportation.

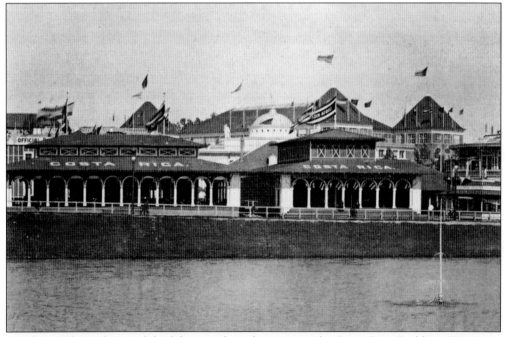

On the northern shores of the lake's southern lagoon was the Costa Rica Building. Nicaragua and Costa Rica joined together to create an exhibit that showcased scenes from their countries in a small theater. Costa Rica encouraged the exposition visitors who brought their own food to picnic at its building and sample the Costa Rican coffee that was sold there.

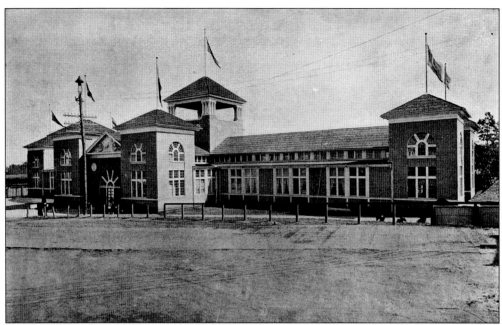

The Negro Building is seen here. It was located in the southeast corner of the exposition near today's Tenth Street and contained 25,000 square feet of floor space. African American contractors were hired by the exposition directors to build the structure at a cost of $10,000. This building was the first exposition building in the world devoted to exhibiting the accomplishments of post-slavery African Americans.

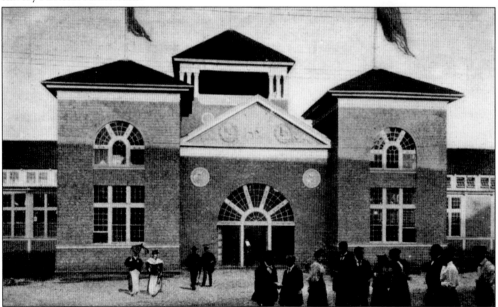

Pediments over the doorways to the Negro Building showed African American progress, carved in staff. The carvings included a slave woman, Frederick Douglass, and a mule and plow that represented former slaves plowing their own fields and not plowing for another, as they had done only 30 years before the exposition. This photograph was in the December 5, 1895, edition of *Leslie's Weekly*.

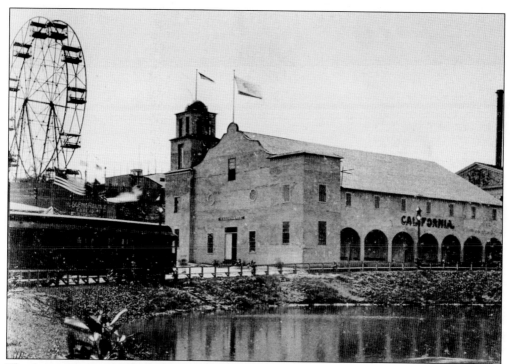

The fragrance of more than 6,000 oranges met fair visitors inside the California State Building, wafting from a 30-foot-tall tower of oranges in the center of the building. The California State Building was the largest state building at the exposition, measuring 70-by-123 feet, and was located west of the Negro Building. It was built in an Old Spanish Mission style with funds from a private citizen of California.

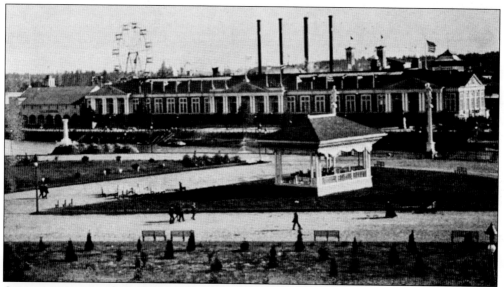

Continuing westward along the southern shores of Lake Clara Meer was Machinery Hall. This building contained the machinery that worked the entire park—from the electric lights to the water pumps—as well as exhibits of machinery for educational purposes. It is seen here from the north with the California State Building on the far left.

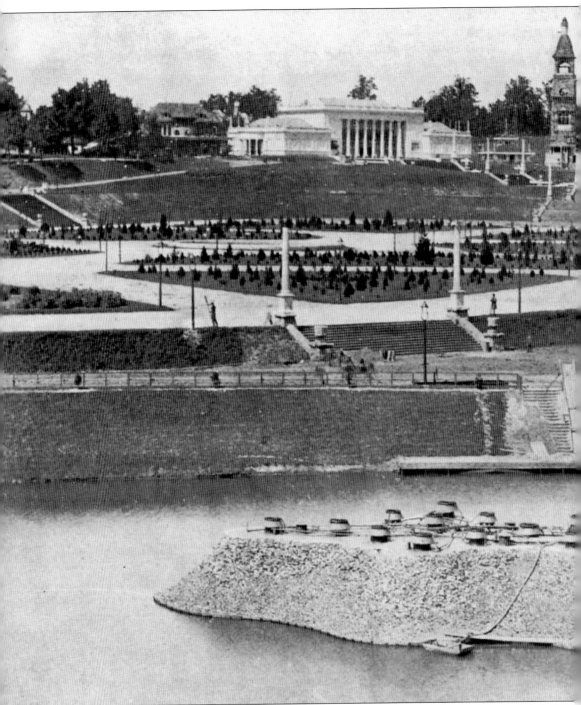

Atlantis, the electric fountain on an island in Lake Clara Meer, was one of the most talked about and memorable features of the Atlanta Exposition. It was designed by Luther Stierenger, who was the consulting electrical engineer in Atlanta and at the 1893 Columbian Exposition in Chicago. Stringing lights on buildings in a pitch-black field amazed fair visitors, and Stierenger was considered the guru of electric lights. The fountain could make pictures 150 feet in the air

with colored lights and water in the shapes of wheat sheaves, lilies, and curtains. It could make a giant mist bank with opalescent colors. For the first month, the fountain was a complete failure; divers worked to secure underwater cables without success, including an Atlanta woman diver whose identity remains unknown.

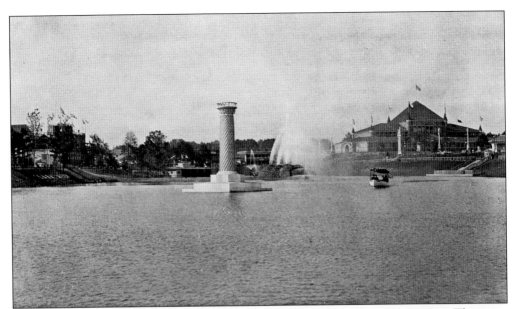

An electric launch circles the Floating Electric Tower of Lights in Lake Clara Meer. The tower is viewed here from the east looking toward the boathouse with Machinery Hall on the left. The Agricultural Building can be seen to the right. The spray of water behind the tower is the electric fountain.

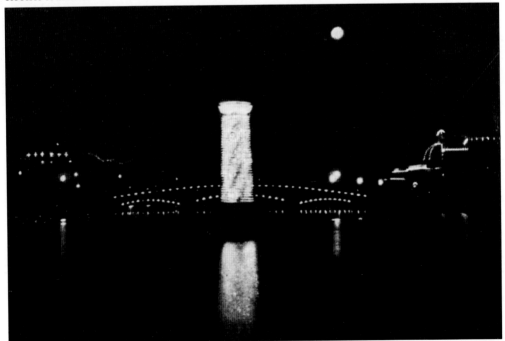

Seen from the opposite direction, the Floating Electric Tower seemed miraculous to the late Victorians attending the Atlanta Exposition, as did all of the night lights. Behind the tower, the bridge over the lake can be seen, outlined in lights. The dangers of electricity were not fully understood; people were amazed when an electrician was killed by touching a live wire in Machinery Hall with one finger.

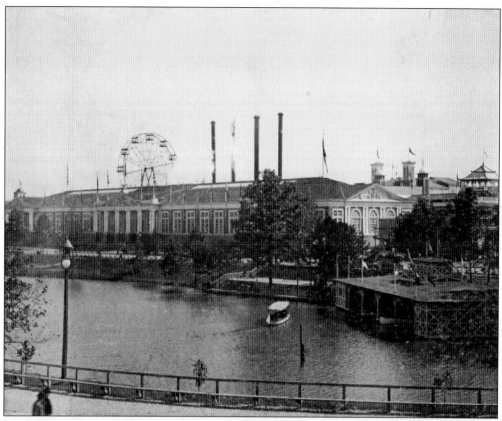

Machinery Hall is viewed here from a northwesterly position, showing the boathouse that was located near today's Lake Clara Meer dock at the Visitor Center. An electric boat was in the lake. Midway Heights, the carnival area of the fairgrounds, was located behind Machinery Hall, where the Phoenix Wheel can be seen.

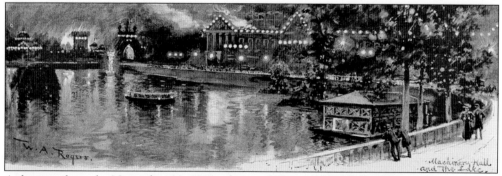

A drawing from the November 30, 1895, edition of *Harper's Weekly* depicts a night view of the western portion of the lake. The exposition had its own lifeguards, who made the boathouse into what they called their "life saving station." As the weather turned colder during the exposition, the lake put off an iridescent mist in the evenings because some of the buildings released hot water into Lake Clara Meer.

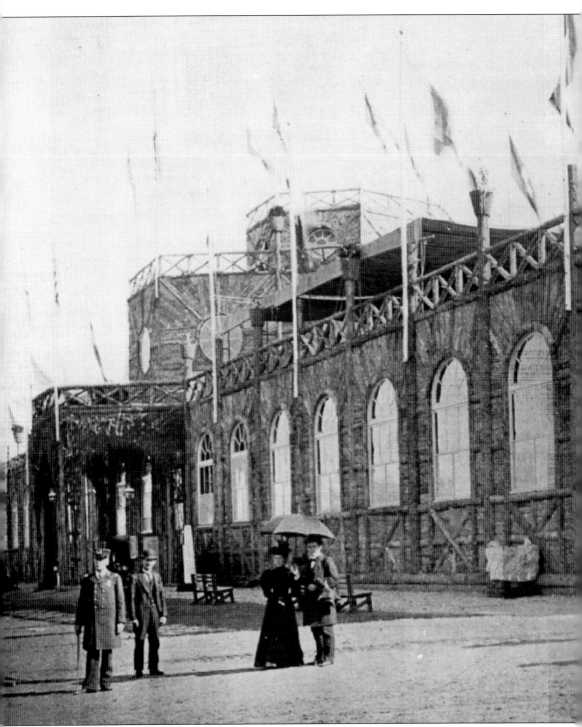

The Minerals and Forestry Building was located in the southwestern corner of the exposition near Machinery Hall. Thirty types of Southern wood were used in the construction of the building. This photograph shows how the exterior siding was made of wood that was left in its natural condition with the tree bark in place. Posts, sills, girders, rafters, and braces were made

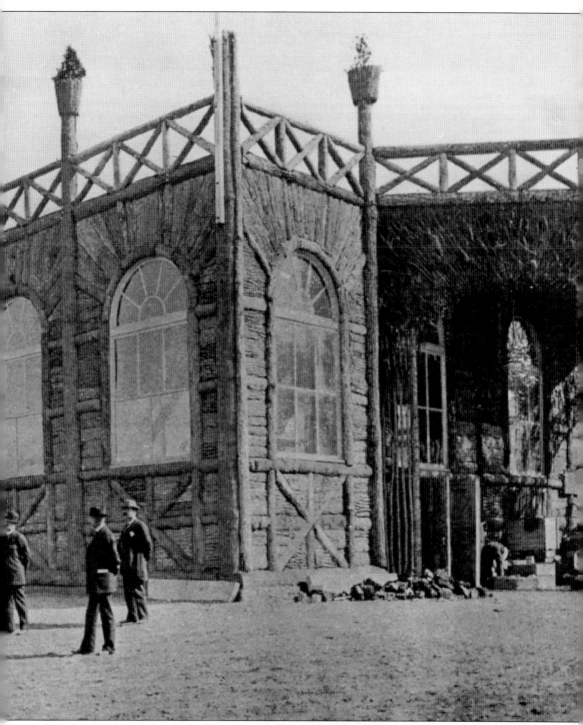

of whole trees covered in bark. The entrances to the building were elaborately trimmed with intertwined twigs, branches, and moss. An octagon-shaped center extended 30 feet above the roof. The building contained 26,000 square feet of space with exhibits of natural resources such as gems, timber, and plants.

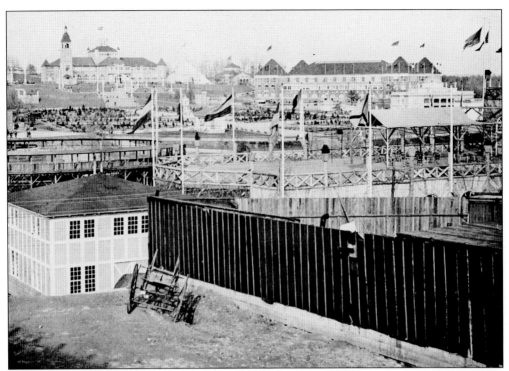

This rare photograph shows a view from behind the Minerals and Forestry Building looking north. The building's crossed-timber rooftop trim is unmistakable. A restaurant was located on the large, flat roof of the Minerals and Forestry Building. The round structure in the center left of the photograph was the bullpen in the Mexican Village, and the light-colored building on the left side was a warehouse.

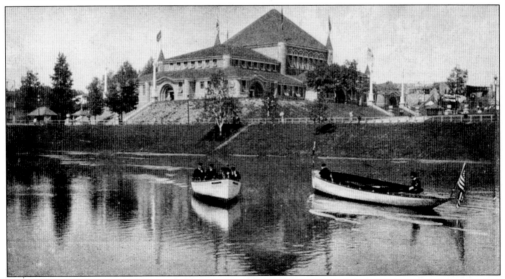

Two boats, each with a uniformed captain, are seen on Lake Clara Meer. This scene shows a view from the southern portion of the lake looking northwest. The large building in the background is the Agricultural Building. Today a playground called the Noguchi Playscape, designed by architect Isamu Noguchi in 1976, crowns the hill where the Agricultural Building was once located.

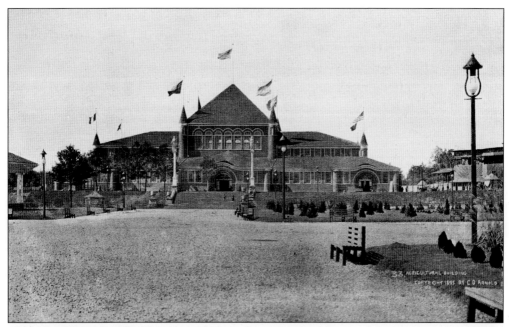

The Agricultural Building was the only large exposition building in the southwest corner of the fairgrounds, and its exhibits proved that almost anything could be grown in Southern soil. Its interior had 40,000 square feet of floor space. During the exposition's construction period, laborers moved dirt by hand to build the high knoll upon which the building was situated.

Between the Agricultural Building and Piedmont Avenue, the tiny Dairy Building stood all to itself. The Atlanta Dairy Company, which distributed milk to Atlanta and to the exposition, operated a lunch stand inside the building that served milk, bread, and butter. The P. M. Sharples exhibit inside the building displayed churns and cream separators—a new invention that rapidly took the cream out of the milk.

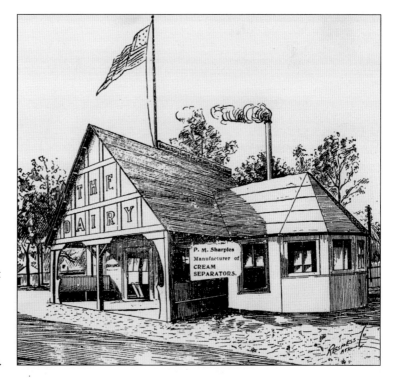

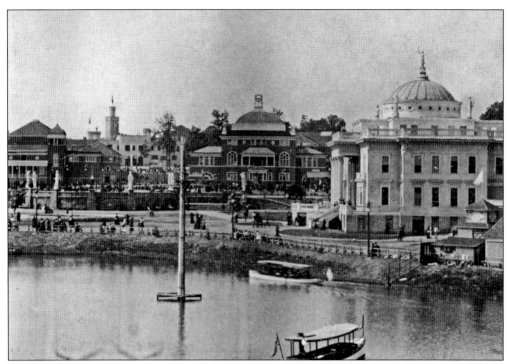

On the west side of the fairgrounds, the Auditorium and the Georgia State Building were perched at the incline leading from the Fourteenth Street entrance to the Plaza. In the center of the photograph, the Georgia State Building can be seen with the Auditorium to the left. The white building in the right foreground is the Woman's Building.

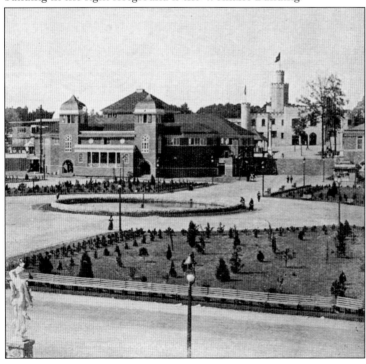

The Auditorium is seen here with the castle-like Administration Building in the background. Its dimensions were 135-by-200 feet, and it could seat 2,000 people at one time. There were restaurants located inside the building. Many speeches were given here, including the famous "Atlanta Compromise" speech by Booker T. Washington.

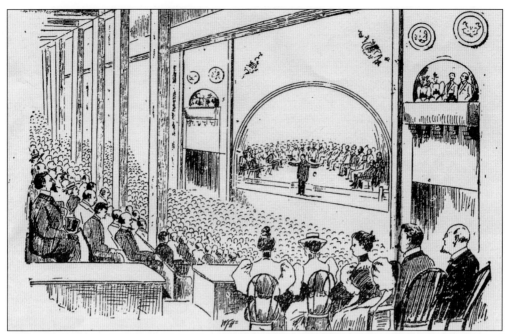

This drawing from the September 18, 1895, edition of the *Atlanta Journal* shows the inside of the Auditorium. The interior walls were painted a pale blue, and the wood was stained a cherry color. In inclement weather, concerts scheduled to be given at the two Plaza bandstands were given here.

Most large meetings took place in the Auditorium, except for those pertaining to women, which were held inside the Woman's Building. Fall weather in Georgia is often similar to summer weather; the building conditions must have been stifling the first two months of the exposition with 2,000 people inside. This photograph shows the front entrance to the Auditorium. It faced the Fourteenth Street entrance.

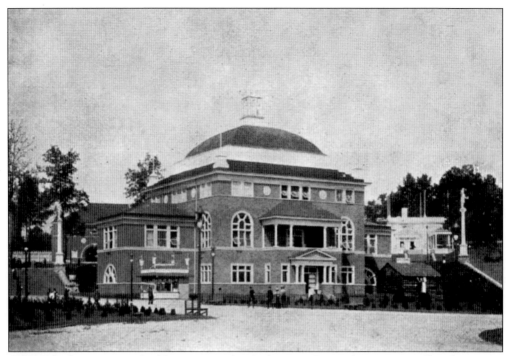

Georgia had its own state building next to the Auditorium. It was three stories tall with an open dome that rose 88 feet from the floor. The dome was crowned with a model of the state coat of arms. Over the entrance was a pediment with a carving of Gen. James Oglethorpe. A tea plant was grown outside near the doorway that was allegedly from an expedition to China in 1854.

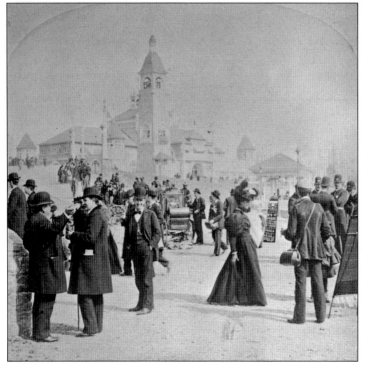

The cover image shows activity on the Plaza during the Atlanta Exposition. In the center of the photograph is an example of a herdic buggy. Herdics were small, one-horse carriages that served the purposes of a taxicab in the late 19th century. (Courtesy of Georgia Archives, Vanishing Georgia Collection, Image No. 0676.)

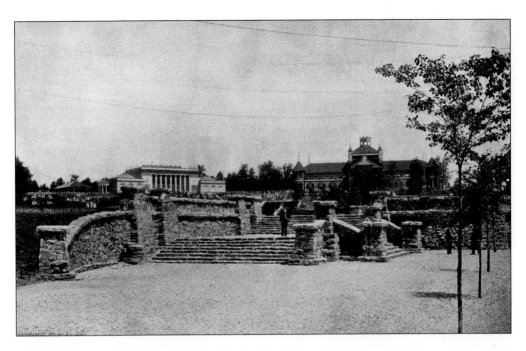

Above, a man stands on the stone structure that was built on the eastern side of the Plaza. All of the stones used in the staircases, urns, and buildings at the exposition were quarried on the fairgrounds. Named the Terraces in this photograph, the structure still exists today and is generally called the Parapet. The photographs above and below were taken during the construction phase of the exposition. Notice that the Chimes Tower had not yet been built between the Fine Arts Building and the U.S. Government Building on the northern hill. The statues were not in place on the Plaza staircases or on the Parapet.

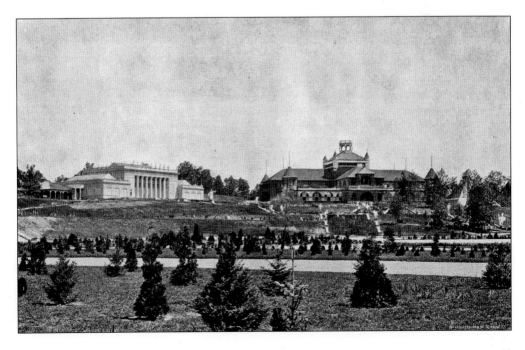

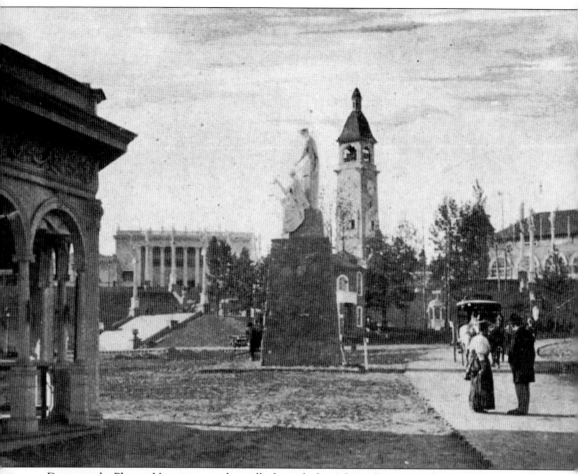

Down on the Plaza, a Victorian couple strolls through the Atlanta Exposition fairgrounds, seemingly in the path of a two-horse carriage headed their way. The couple was standing directly in front of the Manufactures and Liberal Arts Building with a concessions building on the left—Nunnally Company Fine Candies of Atlanta. This company was given the sole right to exhibit and sell candies on the exposition grounds. Nunnally sold candy inside the Manufactures and Liberal Arts Building as well. The couple is standing on a plank or wooden road that was built by the Atlanta Herdic Company throughout the exposition grounds at its own expense. Herdic fare was 5¢. Carrying thousands of heavily-dressed ladies around the exposition grounds was lucrative work. Outside the grounds on the city streets, the herdic company was an excellent response to the Atlanta streetcar companies' price gouging during the exposition.

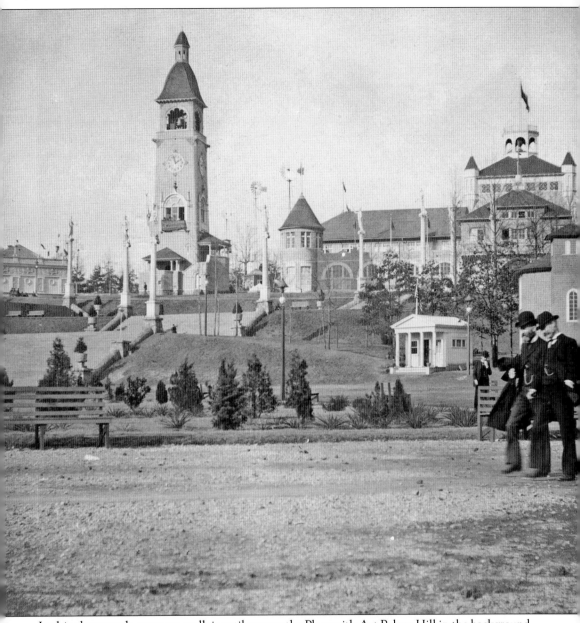

In this photograph, two men walk jauntily across the Plaza with Art Palace Hill in the background. The grand staircase leading to the Chimes Tower and other buildings on the hill is the only exposition construction in this view still extant. Visitors did not begin crowding the Atlanta Exposition until November, indicating this photograph was probably taken in September or October since the men seem to be alone. At night, the Chimes Tower in the center looked like a lighthouse because of electric lights that were installed on the top of the building. There were two powerful searchlights in operation on the grounds in the evenings. One searchlight was on Machinery Hall, and it shined on the northern hill and particularly on the Fine Arts Building. The other searchlight was located on the opposite side of the park, on top of the U.S. Government Building.

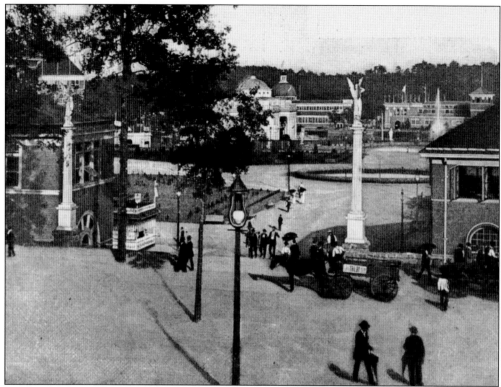

Upon entering the exposition fairgrounds through the main entrance at the Administration Building, visitors would encounter this view of the Plaza. This *Harper's Weekly* image, entitled "Across the Plaza from the Administration Building," from the week of October 19, 1895, shows a view between the Georgia State Building on the left and the Auditorium on the right.

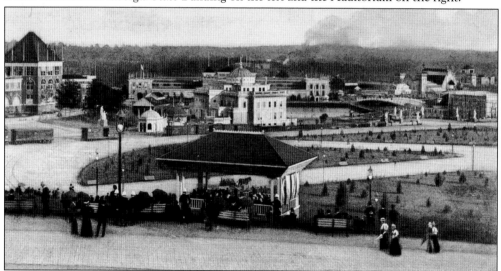

Harper's Weekly titled this sweeping image in the October 19, 1895, edition "View of Band-Stand and Plaza from New York State Building." There were two bandstands in the park: the one shown here and one at the southern end of the Plaza. Walkways were built of crushed stone or board planks, like the one seen here in the foreground.

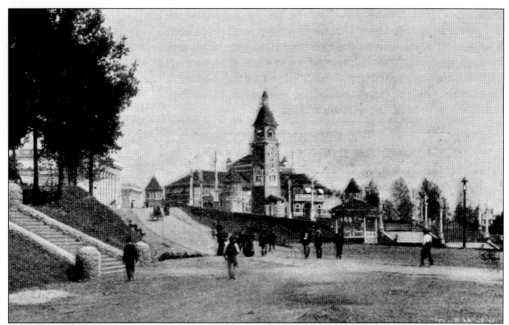

In this November 16, 1895, *Scientific American* image, a path for horses, carriages, buggies, and wagons meanders down into the Plaza from the northern hill. While this downhill road into the Plaza was permanent, temporary wagon paths and train tracks were set up to build the fair and to bring the heavy exhibits into the buildings.

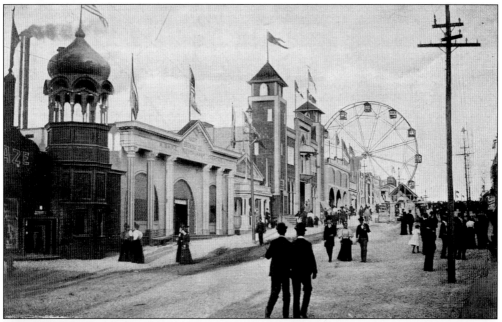

Midway Heights, the amusement portion of the Atlanta Exposition, ran east to west behind the Minerals and Forestry Building, Machinery Hall, and the California State Building in the southernmost part of the fairgrounds. The area was once a hill and was flattened by hand through Fulton County convict labor—the county's contribution to the exposition. Today the area stretches along Tenth Street and is known as Oak Hill.

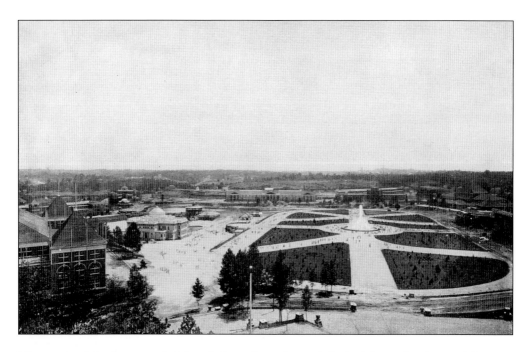

This view of the fairgrounds (above) shows how the park looked from the dome of the U.S. Government Building on the northern hill of the park. The view below shows how the park looked from the opposite direction—south looking north. In every way but financially, the Atlanta Exposition was a success; the local Atlanta businessmen bailed the exposition out of debt in November. It was a city unto itself. The exposition had its own power sources, military guards, government, post offices, food, transportation, newspaper, and entertainment. To build and present this fair to the world cost approximately $3 million. More than 1 million people visited the Cotton States and International Exposition during the 100 days it existed.

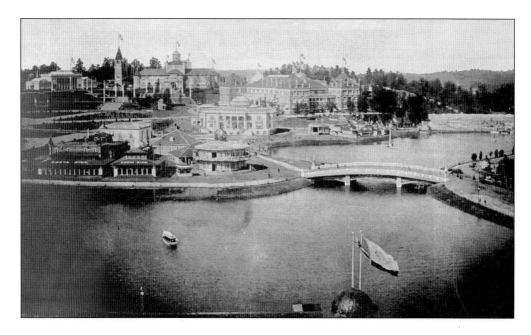

Two

CELEBRATIONS AND CELEBRITIES

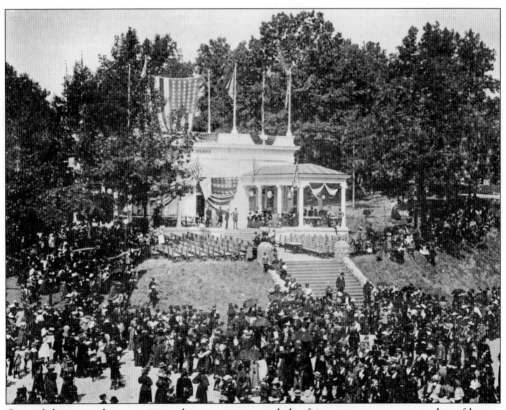

One of the ways the exposition directors promoted the fair was to announce a day of honor that celebrated a person, state, city, or organization. Some celebrations were Pennsylvania Day, Diplomats Day, Chinese Day, Postmasters Day, and Cincinnati Day. The fairgrounds were flooded with visitors on days that the festivities were exceptional or when a famous person attended. The photograph here shows the Pennsylvania State Building on Liberty Bell Day.

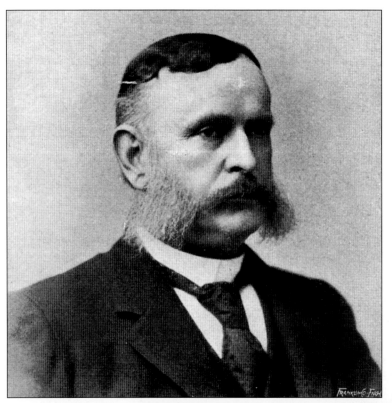

William Arnold Hemphill is credited with having the brilliant idea of Atlanta hosting an exposition. He was the business manager of the *Atlanta Constitution* and promoted the fair through the newspaper. Hemphill, as the first president of the Exposition Company, conducted the preliminary work of organizing the fair. He stepped down for business reasons and turned the fair over to a new president, Charles A. Collier.

Hoke Smith, who was later governor of Georgia, was Secretary of the Interior under Pres. Grover Cleveland during the exposition. He was instrumental in convincing Congress to appropriate federal funds to the fair. On November 2, 1895, Smith promoted the exposition in the *Atlanta Journal*: "The Negroes and the whites are perfectly harmonious in the South. . . . There is no place where a man can make money quicker or surer."

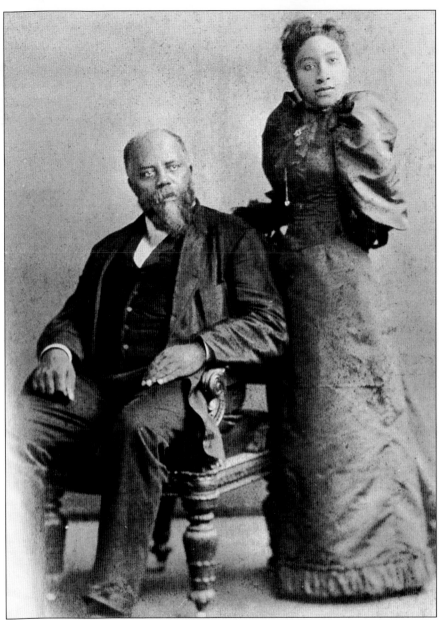

In addition to white Atlanta businessmen, three African Americans went to Washington, D.C., and addressed the Congressional Committee on Appropriations to secure federal funds for the exposition: Bishop Wesley John Gaines and Bishop Abraham Grant of the African Methodist Church and Booker T. Washington of the Tuskegee Institute in Alabama. Bishop Gaines is seen here with his wife, Julia. In Washington, he said that the African American speakers had come to hold up the hands of the white men in asking for an appropriation because it would give their race an opportunity to make an exhibit of its development and progress—an opportunity they had never had. Gaines spent the first 25 years of his life as a slave, and his background, intelligence, eloquence, and strong words influenced the congressional committee. As one of the founders of Morris Brown College in Atlanta, Gaines's influence continues today. He and his wife lived on Auburn Avenue in Atlanta and were active members of the African American community.

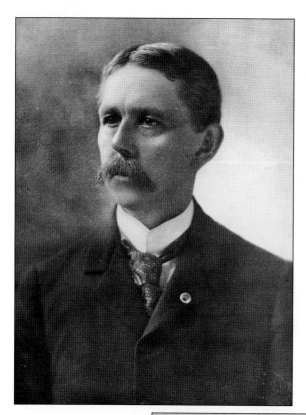

Charles A. Collier was president and director general of the Exposition Company during most of its existence. It was he who presided over the fair during the 100 days it ran, although he was ill during part of that time. Collier was a firm leader, and his goal was to make the Atlanta Exposition of interest to all people. Collier was well respected in Atlanta's social and business circles.

Grant Wilkins was chairman of the Committee on Grounds and Buildings and chief of construction at the Atlanta Exposition. He designed the grounds for the fair and was known as a demanding and meticulous manager. Atlantans may thank him for the attractive layout of Piedmont Park that exists today.

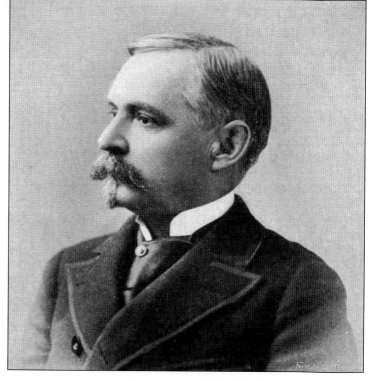

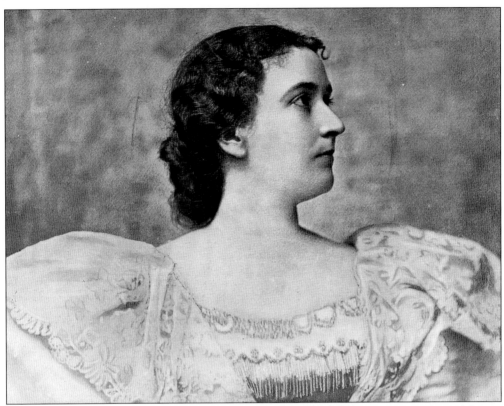

The most honored and revered lady involved with the Atlanta Exposition was Emma Mimms Thompson, president of the Board of Women Managers. An Atlanta socialite, she showed intelligence and dignity in her position. She raised money, presided over the Woman's Building, and spoke at the Opening Day ceremony of the exposition in front of thousands—a first for a Southern woman.

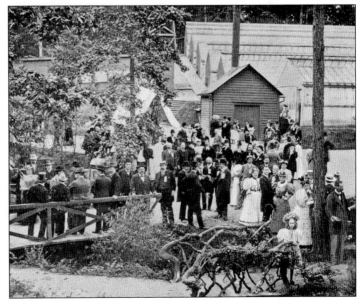

For months before the Atlanta Exposition opened, its directors courted the national press. Emma Thompson hosted a lawn party at her country home, Brookwood, a half-mile from the exposition grounds, to honor Washington, D.C., press correspondents and ensure their public support of the fair. The lawn party is seen here with greenhouses in the background. Her husband, Joseph Thompson, owned a flower business.

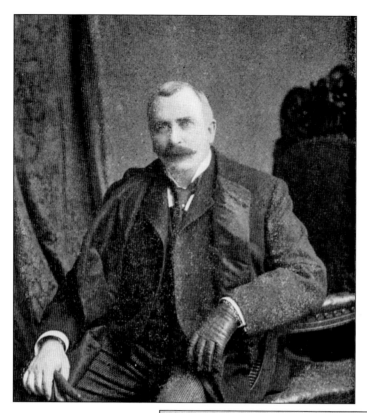

Twelve main buildings made up the Atlanta Exposition, and Bradford L. Gilbert, seen here, designed nine of them. This New York architect created the buildings to be Romanesque in style. They were broad and boxy, gray-shingled, with moss-green roofs and white trim. Made of abundant Georgia pine, the buildings contributed to a natural, soothing effect the park was meant to convey and were cost-efficient.

The Woman's Building at the Atlanta Exposition was designed by a woman architect: Elise Mercur of Pittsburg, Pennsylvania. She won a $100 prize for her design. The building was the most expensive for its size at the fair and was the only building to have a cornerstone laid. Inside the cornerstone were a number of items, including a photograph of Mercur and a copy of *Woman's Journal*.

At the Opening Day ceremony, Pres. Grover Cleveland started the mechanical wheels of the fair in motion from his summer home in Buzzard's Bay, Massachusetts. He pushed a button that sent an electric signal to Machinery Hall at the exposition, thereby turning on the electricity in all the buildings at 5:54 p.m. This cartoon of the president was on the front page of the September 18, 1895, *Atlanta Journal*.

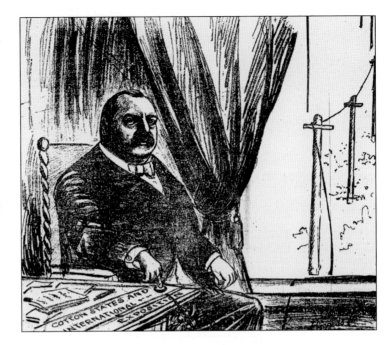

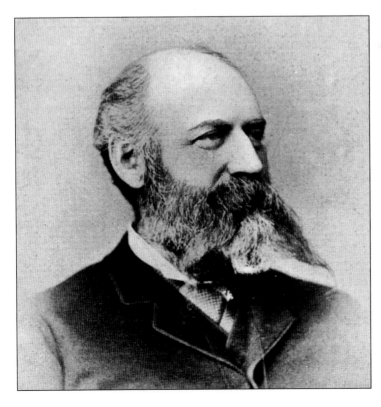

Former governor Rufus Brown Bullock was chairman of the Committee on Ceremonies and Ceremonial Days of the exposition. Opening Day began with a parade from downtown, through the city festooned with national colors, to the gates of Piedmont Park, and then to the Auditorium for speeches. Bullock was master of ceremonies at the Opening Day exercises and introduced the speakers who represented the exposition, the state, and the city.

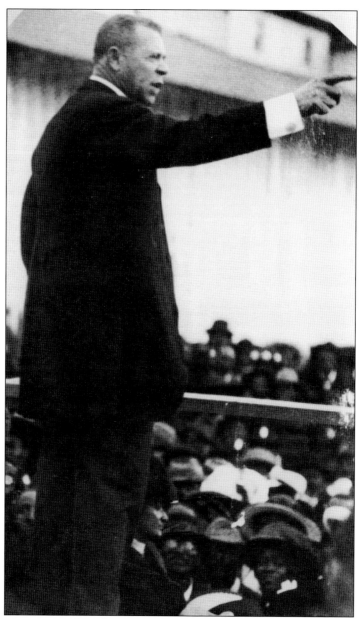

Tuskegee Institute principal Booker T. Washington agreed to address the Atlanta Exposition crowds on one condition: that he do so at the Opening Day exercises. It was there that he gave his famous "Atlanta Compromise" speech. Washington advocated racial harmony through social segregation in exchange for black economic opportunity and education. He said in this speech, "In all things that are purely social, we can be as separate as the fingers, yet one as the hand in all things essential to mutual progress." Later criticized as an accomodationist, he nonetheless made one of the most significant speeches in American history. Regarding the speech, Washington said, "The thing that was uppermost in my mind was the desire to say something that would cement the friendship of the races and bring about hearty cooperation between them." Washington is shown making a speech at an unidentified location. There are no known photographs of his exposition speech.

On September 21, 1895, the Atlanta Exposition honored all veterans of the Civil War with Blue and Gray Day. Thousands of veterans, both Union and Confederate, came to Atlanta for a grand reunion at the exposition. Pictured here is Gen. John B. Gordon, who was governor of Georgia from 1886 to 1890. He was commander in chief of the Confederate veterans. (Courtesy Library of Congress, LC-DIG-cwpbh-04706.)

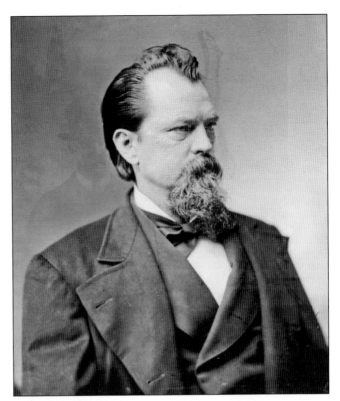

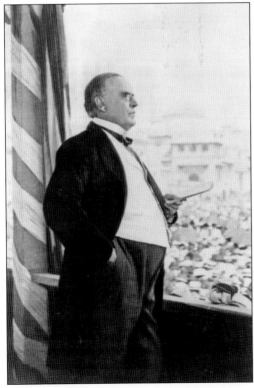

Gov. William McKinley, who became U.S. president two years later, spoke on Blue and Gray Day. "The arrows of death which fell thick and fast all about this region are now carrying only messages of love and affection and fraternal union." This image shows McKinley making his last public speech; he was assassinated at the Pan-American Exposition in Buffalo in 1901. (Courtesy of the Library of Congress, LC-USZ62-83133.)

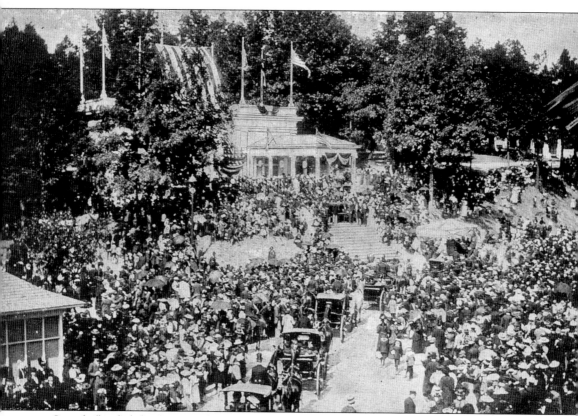

Crowds flooded the fairgrounds on Liberty Bell Day. October 9 was set aside for the exposition to officially receive the Liberty Bell from the city of Philadelphia with pomp and circumstance. Liberty Bell Day drew the first large crowds to the exposition. There had been resistance from some citizens of Philadelphia, and even a lawsuit to prevent the bell's travel, but eventually the bell made the slow ride to Atlanta aboard a special train. A poem was written by David A. Bell to honor the bell called "Welcome, Old Liberty Bell." It was published in the exposition's "Daily Programme of Events." Some of it is as follows: "Welcome to Georgia, dear old bell! / To old and young thy story tell: / How when 'neath Britain's yoke we lay, / Thy notes proclaimed our natal day, / Proud day of liberty."

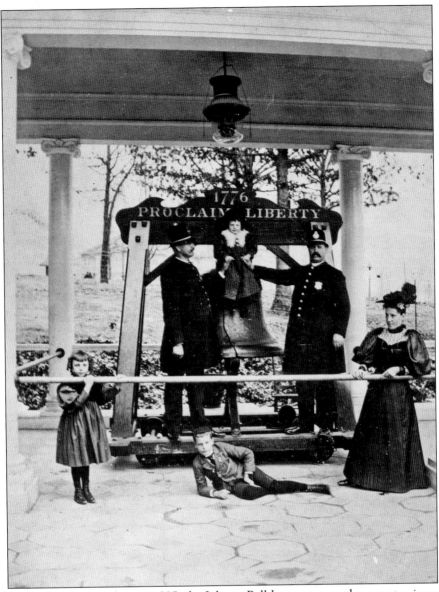

From October 9 to December 31, 1895, the Liberty Bell hung on an oak apparatus in an open porch at the Pennsylvania State Building. To guard the bell, four Philadelphia policemen traveled with it and lived in the Pennsylvania State Building during the exposition. Two of them are pictured here with the bell, a woman, and three children, one of whom is sitting atop the great bell. More than 30,000 people visited the Atlanta Exposition on Liberty Bell Day; some of them sat in the trees to get a glimpse of the bell. A parade escorted the bell to the exposition grounds, and Georgia governor William Yates Atkinson, Atlanta mayor Porter King, and Philadelphia mayor Charles Warwick addressed the crowds. The Liberty Bell also appeared at the following expositions: the 1885 Worlds Industrial and Cotton Centennial Exposition in New Orleans, the 1893 World's Columbian Exposition in Chicago, the 1902 South Carolina Inter-State and West Indian Exposition in Charleston, the 1904 Louisiana Purchase Exposition in St. Louis, the 1915 Panama-Pacific Exposition in San Francisco, and the 1915 Panama-California Exposition in San Diego.

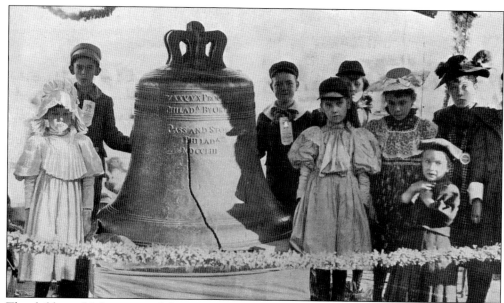

The children of Atlanta owned the exposition on Liberty Bell Day. All city schools had taught the history of the bell the previous day. Streetcars allowed children to ride free to the exposition, and the admission prices were reduced for the little ones. A chorus of 2,000 children sang "America" to the bell. Approximately 12,000 children entered the fairgrounds to see, and perhaps touch, this great symbol of national pride.

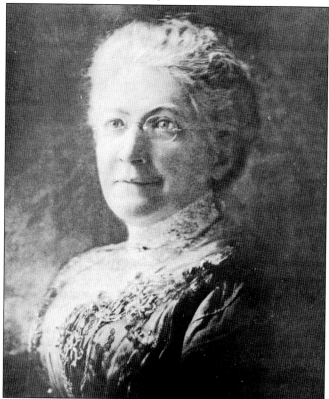

Nellie Peters Black was in charge of the Hospitals and Charities Committee at the Atlanta Exposition, which oversaw the exposition hospital and model kindergarten class. Born into a wealthy family as daughter of Atlanta businessman Richard Peters, she volunteered in philanthropic organizations her entire life. The exposition baby nursery, which charged 25¢ per day, was also under her supervision.

Georgia governor William Yates Atkinson lent his official presence to the exposition on numerous occasions. He was present at the Opening Day exercises but was unable to address the crowd because he was still weak from a recent illness. The governor and his wife, Susan Atkinson, were a credit to the state during the exposition, as they entertained government leaders from around the world.

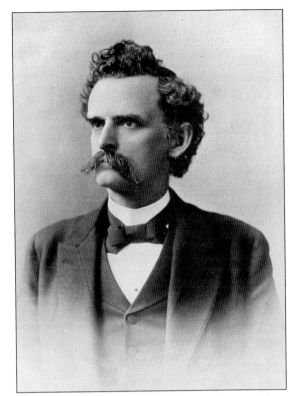

This drawing by newspaper artist A. J. Kellar appeared in the October 5, 1895, edition of *Harper's Weekly*. It was titled "Ballroom in Capital City Club House, The Social Side of the Atlanta Exposition." During the exposition, Atlanta's elite entertained visitors and themselves with lavish balls, luncheons, and receptions in clubs, hotels, and private homes. Atlantans wanted to leave a lasting impression of legendary Southern hospitality upon their guests.

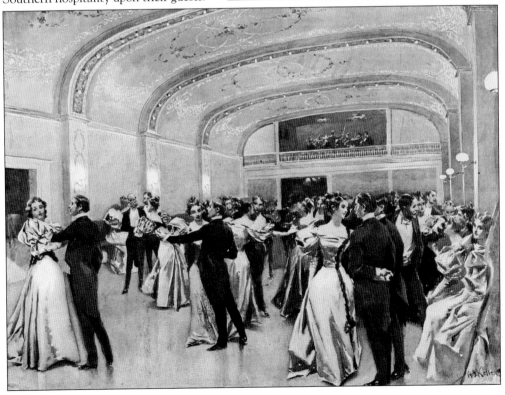

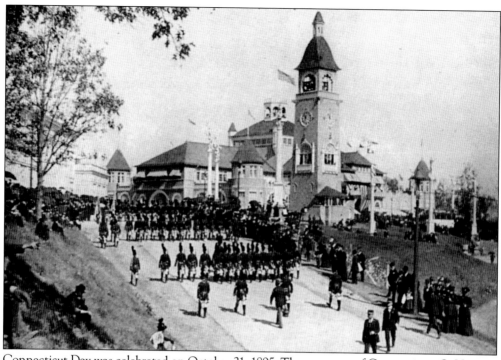

Connecticut Day was celebrated on October 21, 1895. The governor of Connecticut, O. Vincent Coffin, was escorted by two companies of the famous Governor's Foot Guard. They are seen on parade with the 5th Georgia troops. On that day, Governor Coffin said, "It cannot be that we must go on forever insisting upon stirring the embers of the fiery controversy now a third of a century in the past."

Henry J. Pain filled the skies above the exposition with fireworks, from two-hour reenactments of war battles to portraits of women in the sky. He engineered a replica of Niagara Falls that was 13,600 square feet of fire in the sky. Almost every celebration or celebrity was honored though explosions of light above Piedmont Park that were designed by Pain.

President's Day was on October 23, 1895, to honor the visit of Pres. Grover Cleveland to the Atlanta Exposition. The president's first stop at the fairgrounds was the U.S. Government Building, where he toured the exhibits with his entourage. In front of the U.S. Government Building, a reviewing stand was erected where the troops were presented to the president. The image on the right shows the reviewing stand to the right with the striped awning; the Connecticut Governor's Foot Guard is passing. In the below photograph, Atlanta's Gate City Guard is passing the Fine Arts Building. Both of these photographs appeared in *Leslie's Weekly* on November 7, 1895.

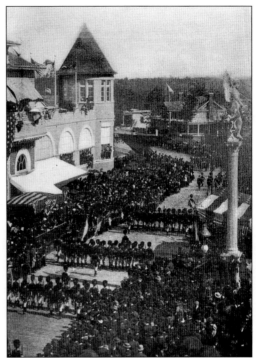

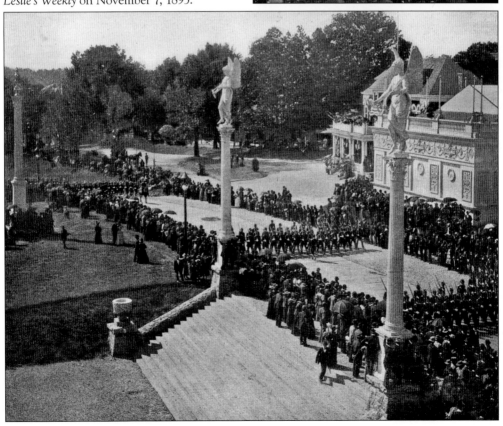

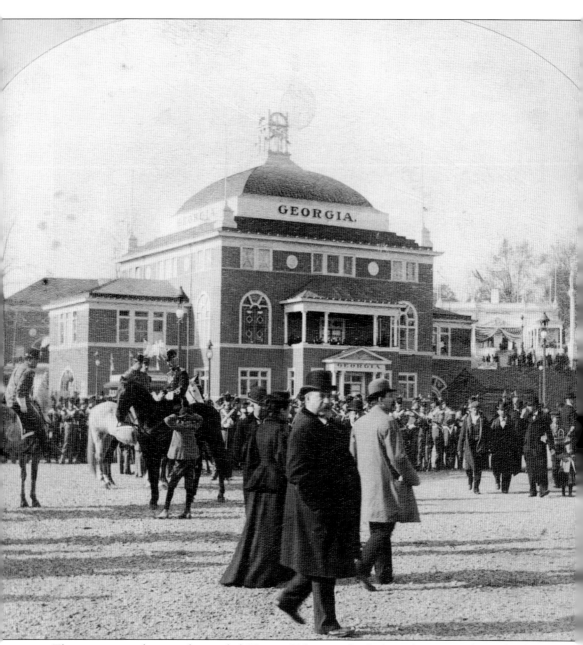

This stereoview photograph, entitled "Grover Taking in the Sights," shows President Cleveland walking in the Plaza outside the Georgia State Building. The president worked hard at the fair. He shook 2,804 hands in 33 minutes. With the crush of eager hand-shakers, the *Atlanta Journal* reported that four women fainted within arm's distance of the president. One witness stated, "The president started with the handshaking business fresh and vigorous, but after a half hour's work, his face was covered with perspiration and his arms were limp." It was estimated that more than 40,000 people entered the exposition gates on President's Day—a record thus far at the exposition. Cleveland stayed one day in Atlanta. He had lunch at the Piedmont Driving Club. In the evening, he attended a 1,000-person reception in his honor at the Capital City Club, which was filled with red American Beauty roses. He left on a train at midnight.

While at the exposition, President Cleveland went to the U.S. Government Building, the Georgia State Building, the Woman's Building, the Negro Building, and the Old Plantation attraction at Midway Heights. This *Leslie's Weekly* photograph was printed in the November 7, 1895, edition and shows fair visitors waiting for the president to exit the Woman's Building.

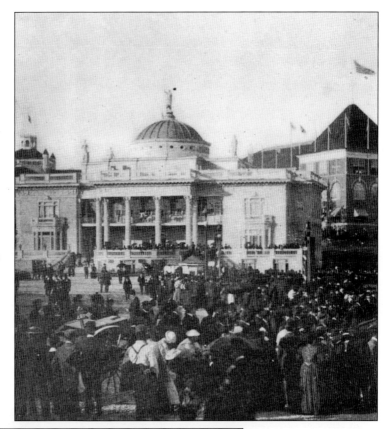

Porter King was mayor of Atlanta during the exposition. He was a lawyer, and his grandfather was Georgia Supreme Court chief justice Joseph H. Lumpkin— the court's first chief justice. Porter had been elected mayor of Atlanta without opposition. He spoke at the Opening Day ceremonies and many other events at the Atlanta Exposition on behalf of the city.

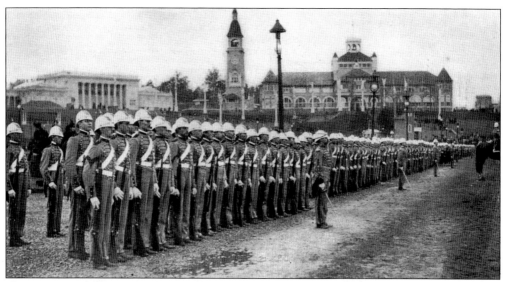

Illinois Day and Chicago Day came on November 11 and 12, 1895. The 1st Regiment of Illinois was escorted to the fairgrounds by the 5th Georgia Regiment. The Illinois troops are pictured on Chicago Day. Witnesses mentioned that their red uniforms were beautiful in the rain. This photograph and the next three images are from the November 28, 1895, *Leslie's Weekly*.

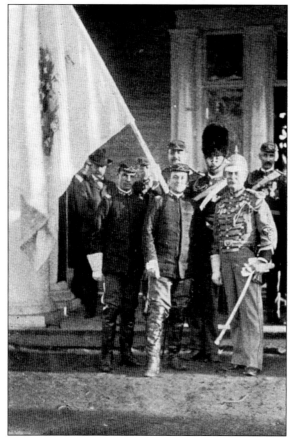

Col. John Slaughter Candler of the 5th Georgia Regiment (front left) and Col. Henry F. Turner of the 1st Illinois Regiment (front right) pose in front of the Illinois State Building with some unidentified troops. Candler was a Georgia Supreme Court justice from 1902 to 1906, and his brother was Asa G. Candler, the founder of the Coca-Cola Company.

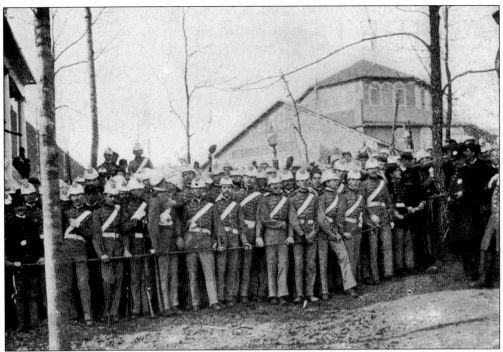

The above image, entitled "The Illinois Regiment Waiting Dinner—Hurry up that Brunswick Stew," shows the troops standing in line for a barbecue dinner on the fairgrounds. The eatery served barbecued shoat, kid, chicken, and mutton, along with Brunswick stew and pitchers of beer. The Illinois troops came with a large group of citizens from their home state. Five trains of 50 coaches came to Atlanta for Illinois Day and Chicago Day. The exposition crowds began growing larger about this time. Up until November, the attendance had been low. Exposition directors blamed the poor attendance upon two things: Georgian farmers had been busy harvesting crops in the fall, and the fairgrounds were unfinished for the first four weeks.

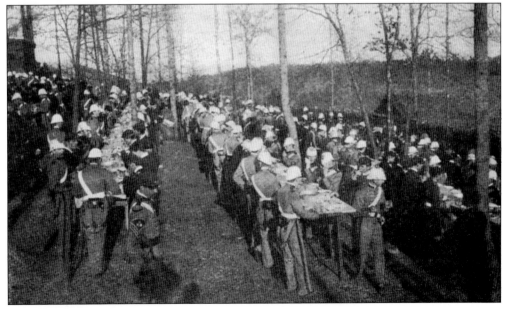

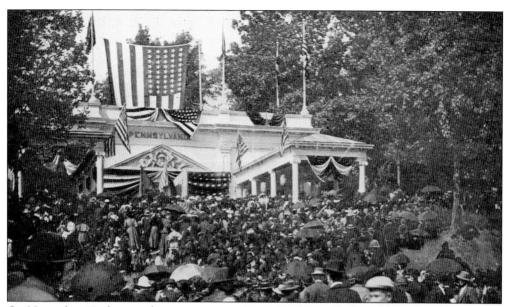

On November 14, the crowds again converged upon Piedmont Park on Pennsylvania Day. This photograph shows attendees listening to Pennsylvania governor Daniel H. Hastings speak from the Pennsylvania State Building. Afterwards 2,000 people were served lunch by the Piedmont Driving Club on its grounds, which were adjacent to the Pennsylvania State Building. Pennsylvania appropriated the largest funds of any state for its presence at the exposition.

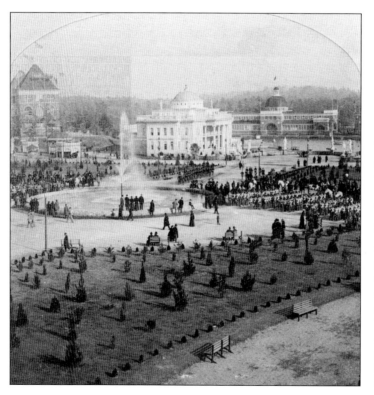

Manhattan Day was celebrated with several military organizations in attendance, including the Burgess Corps of Albany, the 7th New York Regiment, and the Atlanta Gate City Guard. There were more than 1,000 troops, with 100 of them mounted on New York horses, marching on the grounds. This image shows the Plaza on Manhattan Day looking southeast.

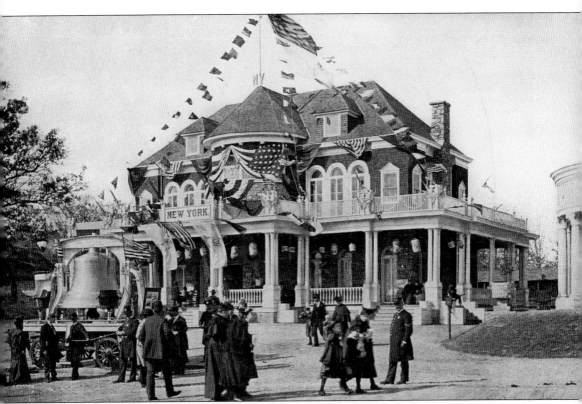

Originally called New York Day, November 25, 1895, was changed to Manhattan Day upon the wishes of the New York City mayor. This image shows the New York State Building on Manhattan Day, decorated with Chinese lanterns and flags for the occasion. The bell to the left in front of the New York State Building was the Columbian Liberty Bell. This bell was cast for exhibit at the 1893 World's Columbian Exposition and was made of donated metal objects collected by the Daughters of the American Revolution. It was supposed to travel the world, promoting peace. Some of the metal objects collected for the bell were amazing pieces of historical interest, such as the keys to Jefferson Davis's house, Simon Bolivar's watch chain, hinges from a door at Abraham Lincoln's Springfield house, George Washington's surveying chain, Thomas Jefferson's copper kettle, and Lucretia Mott's silver fruit knife. Two young ladies rang the bell on Manhattan Day and on Brooklyn Day. The 13,000-pound bell disappeared after the Atlanta Exposition.

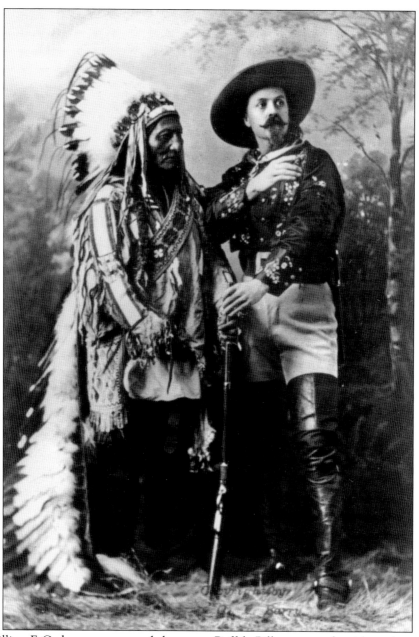

Col. William F. Cody, more commonly known as Buffalo Bill, poses on the right with one of the Native Americans who participated in Cody's Wild West Show and Congress of Rough Riders of the World. Cody's show had performed at the World's Columbian Exposition in Chicago in 1893, and the Atlanta Exposition leaders were hoping for an even bigger turnout. The traveling show had 500 employees, including sharpshooter Annie Oakley. They performed in an arena-shaped field in the southeast corner of the fairgrounds that is known today as the Meadow. Buffalo Bill had negotiated well with the Atlanta Exposition directors; his contract allowed him to have a separate entrance from Tenth Street with no specified number of days required for him to perform. When the weather turned cold and rainy immediately upon the show's arrival, Cody packed up and left. Buffalo Bill was at the Atlanta Exposition from October 28 to November 2, 1895.

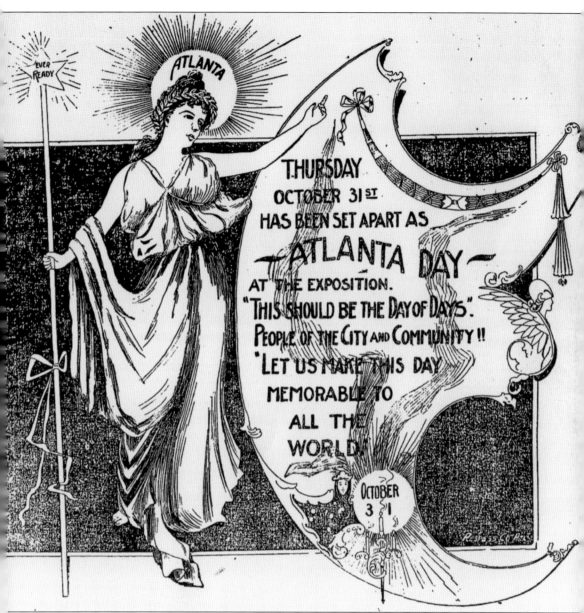

Atlanta Day was advertised in this drawing that appeared in the October 26, 1895, *Atlanta Journal*. There were actually two Atlanta Days because the first one, scheduled for October 31, was a failure because of inclement weather. The second Atlanta Day, on November 28, was a huge success because it was also Thanksgiving Day, South Carolina Day, Savannah Day, Athens Day, Georgia University Day, Football Day, and Samuel Inman Day. To honor Samuel M. Inman, chairman of the exposition Finance Committee, who had personally saved the exposition from bankruptcy, 50,000 admission tickets were printed with his portrait upon them. All Atlanta businesses were expected to close on Atlanta Day, and all Atlanta employers were expected to purchase exposition admission tickets for their employees. The city went to the fair en masse. More than 60,000 visitors entered the park on Atlanta Day.

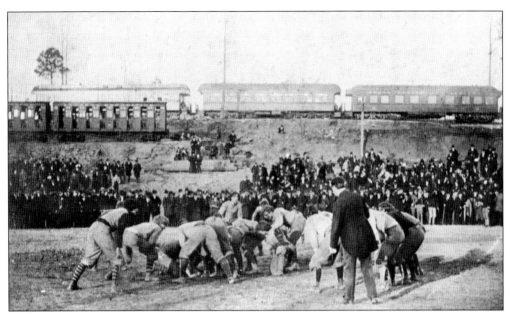

On Thanksgiving Day, 1895, a football game was part of the Atlanta Exposition celebrations. The exposition directors had agreed to let the University of Georgia and Auburn University play their football game on the fairgrounds to draw crowds to the fair. The game was played in the field recently evacuated by Buffalo Bill, now known as the Meadow. Auburn won the game.

Bicycle Day was on November 30, 1895, and the Atlanta Bicycle Club arranged for races to entertain the exposition attendees. Bicyclists were called "wheelmen" in those days. The races took place around the Plaza, starting on the southwest corner, and the wheelmen were required to circle the Plaza track several times.

Three

EXHIBITS AND EXHIBITORS

Everything that could be gathered together in the Victorian, end-of-the-19th-century world made an appearance at the Atlanta Exposition. The fair, with its 6,000 exhibits, was a microcosm of the earth and the earth's inhabitants. It was educational. It was weird. It was fantastic. A few residents of the Mexican Village pose for the camera in this image.

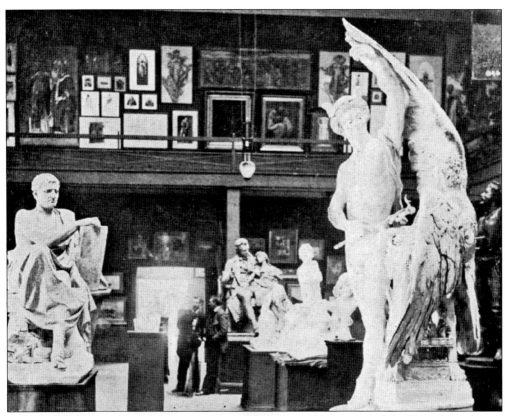

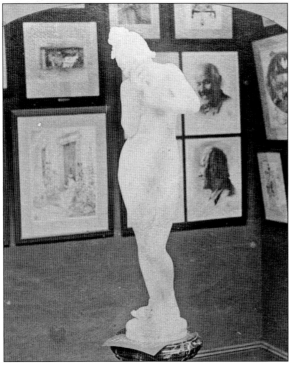

The interior of the Fine Arts Building was filled with paintings and statues. Almost all of the art on display came from outside the Cotton States (Georgia, Alabama, Arkansas, Florida, Louisiana, Mississippi, North Carolina, South Carolina, Tennessee, Texas, and Virginia). Four-fifths of the art was from New York and Philadelphia, and one-tenth was from France, the Netherlands, and Italy. With only natural light and limited electric lighting, buildings were not well lit during the exposition. In the above image, a few men stop to talk in what was probably the morning light coming through an open door; this building would have been crowded during the day. A reporter for the *Atlanta Journal* commented upon this building's popularity on September 28, 1895: "The crowd as a rule likes to look upon the nude."

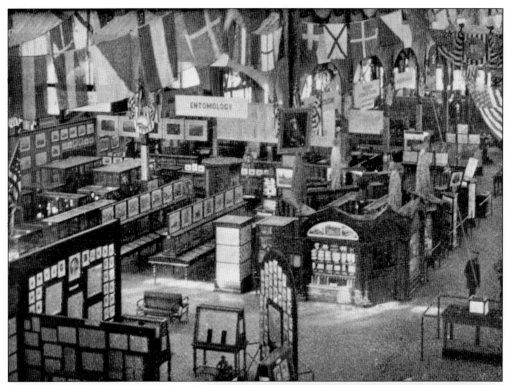

The U.S. government intended for its exhibit to be the best in any exposition thus far by covering a broad range of subjects without overwhelming the visitors with too much information. There were exhibits from the Departments of the Interior, War, Navy, Postal System, State, Treasury, and Justice. The Smithsonian and National Museums also contributed an exhibit. This photograph shows part of the exhibit from the Department of Agriculture.

The two most popular exhibits in the U.S. Government Building were the dead letters exhibit from the U.S. Postal Service and the fisheries exhibit from the Fish and Game Department. The fish were mostly from Southern waters and were displayed in aquariums in a long arcade. This photograph was in the October 19, 1895, *Harper's Weekly*.

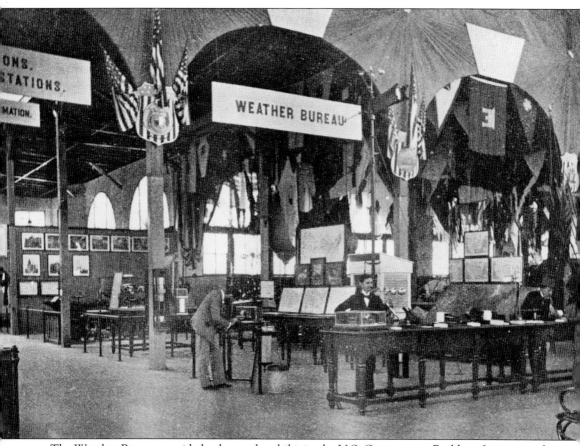

The Weather Bureau provided a thorough exhibit in the U.S. Government Building. It contained charts presenting the features of the country's varying climates, photographs of clouds and lightning, and instruments such as anemometers, wind vanes, rain gauges, thermometers, and barometers. Every day, the Weather Bureau printed reports of weather conditions from around the country and gave a forecast of Atlanta's weather for the day—a remarkable feat for the time period. Some of the fair visitors in this image appear to be studying this exhibit with enthusiasm and possibly learning from the display. It was believed at the time that the World's Columbian Exposition, which had occurred just two years prior to the Atlanta Exposition, had been too vast and all encompassing for the average visitor to enjoy. The Atlanta Exposition was scaled down because of time constraints, finances, and to provide a navigable learning environment.

In the northeast corner of the fairgrounds, behind the Illinois and Massachusetts State Buildings, was the '49 Mining Camp. It was designed to be a humorous replica of the California Gold Rush mining camps of 1849 with rustic cabins, a dance hall, and a graveyard. There were mock duels and fandango dances to entertain the visitors. To the right is a stereoview photograph entitled "The Reception in the '49 Camp." The image below shows the fake graveyard in the camp. Newspaper accounts of the day reported that the fairgoers were amused at the peculiar epitaphs the tombstones displayed and that the only things lacking at the '49 camp were saloons and gold mining demonstrations.

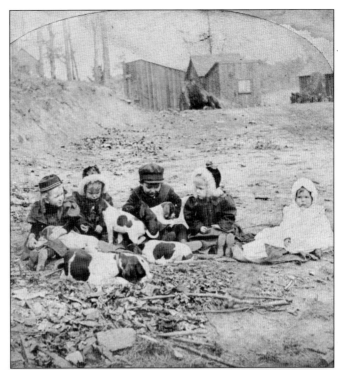

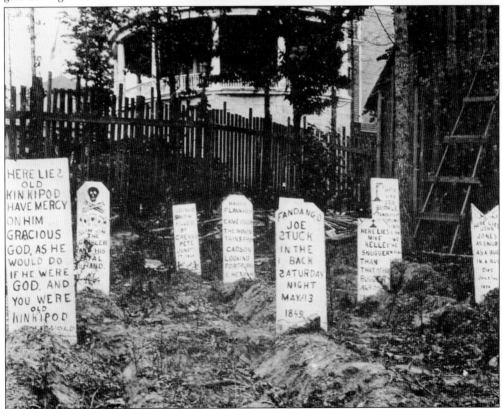

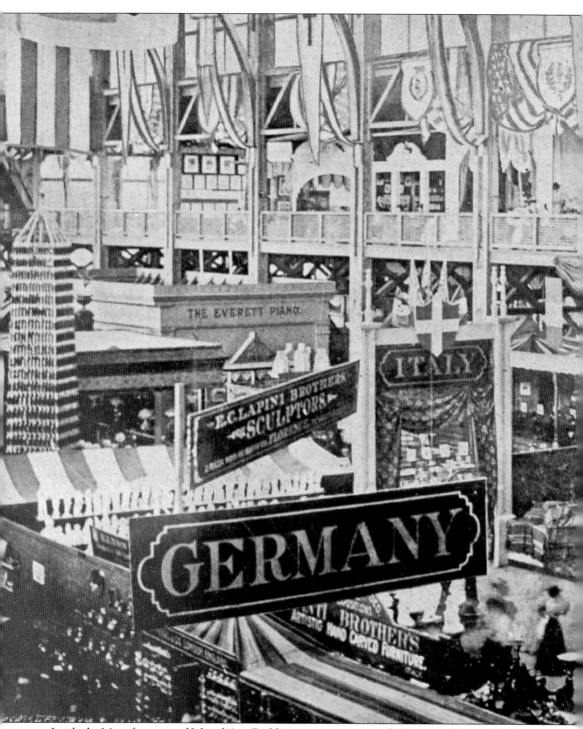

Inside the Manufactures and Liberal Arts Building was an attempt to display everything under the sun made by human ingenuity that could be used and enjoyed by civilization. The exhibits inside this building proved the progress and industry of mankind. Some of the exhibits were chemicals, pharmaceuticals, paints, dyes, varnishes, fire-proofing materials, paper and stationery, typewriters, furniture, upholstery,

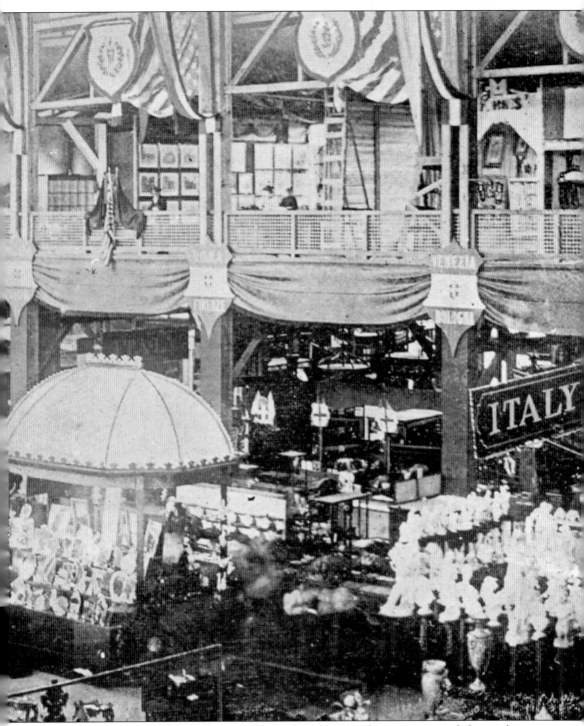

ceramics, tiles, mantels, coffins, glassware, fabrics, fur, rubber, weights, ammunition, lights, cookware, vaults, breads, soaps, telephones, phonographs, statuary, musical instruments, educational displays from every level of education, jewelry, dishes, flatware, silver, architecture, sewing machines, exercise equipment, clocks, rugs, fashion, locks, literature, religions, and home decor.

Two other views of the Manufactures and Liberal Arts Building show the massive collection of necessities and curiosities inside the building. Women particularly enjoyed this building because so many of its exhibits pertained to the home and family. For the men, there was an extensive collection of firearms and tobacco. The Colt revolver was on display, and the Winchester Company sent gold- and silver-mounted rifles and small arms. One of the companies that sold snuff reported to exposition visitors that it sold 6,250,000 pounds of the substance per year. A fire-proofing company invited fair visitors to attempt to burn its asbestos-treated paper, and the attendees were impressed when the paper was impervious to flame. The world's largest book, a business register weighing 360 pounds, was on display.

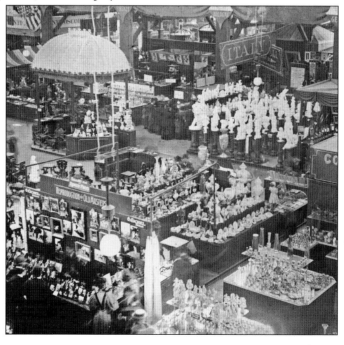

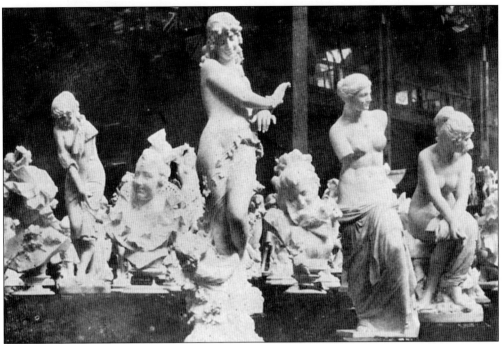

One half of the first floor of the Manufactures and Liberal Arts Building was devoted to exhibits from European countries. The European displays were not official government displays. Most of them were procured through the efforts of Antonio Macchi, who traveled to Europe's cities to obtain the interests of foreign companies and museums. Macchi was the exposition's commissioner general to Europe. The Italian statuary on exhibit was exceptionally fine.

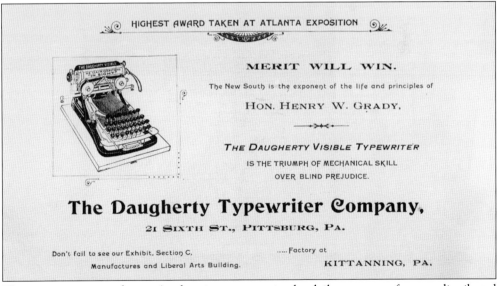

This typewriter manufacturer's advertisement was in the daily program of events distributed throughout the fairgrounds. The Daugherty typewriter was the first that allowed the typist to see letters as they were typed, hence the references to sight and blindness. Ultimately the Daugherty typewriter was not successfully marketed, and Underwood falsely became known as the first typewriter that was not blind.

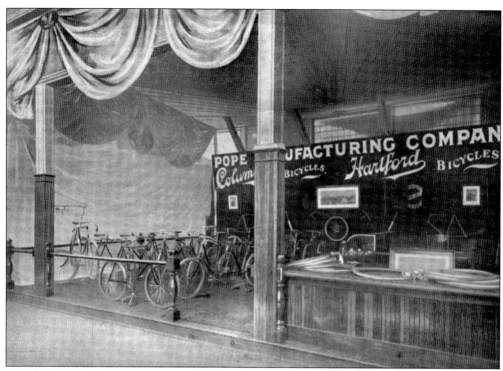

The Pope Manufacturing Company of Hartford, Connecticut, built the Columbia bicycle on exhibit in the Manufactures and Liberal Arts Building. The Columbia was a nationally popular bicycle and was more expensive than many other bicycles at the time. This image is from the *Connecticut Quarterly* of October-November-December 1896.

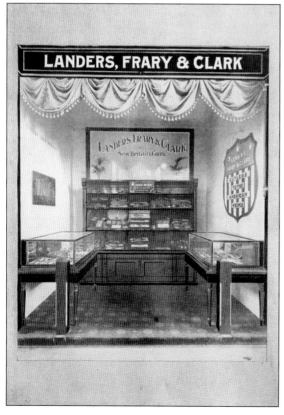

This booth in the Manufactures and Liberal Arts Building exhibited fine table cutlery. The exhibit gave fair attendees the opportunity to learn how the metal went from looking like scrap iron to virtually a work of art. This exhibit received a gold medal from the Atlanta Exposition jurors, a group made up of learned men from around the country, including Booker T. Washington.

A partial view of the Pennsylvania Industrial Educational exhibit in the Manufactures and Liberal Arts Building is seen here. It contained materials from state textile schools, arts schools, manual training schools, deaf schools, sewing schools, builders' trade schools, reform schools, and penitentiary schools. Furniture and building construction were on display in this section of the exhibit.

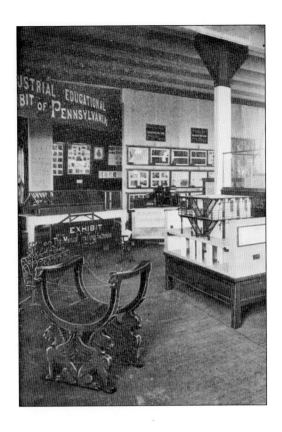

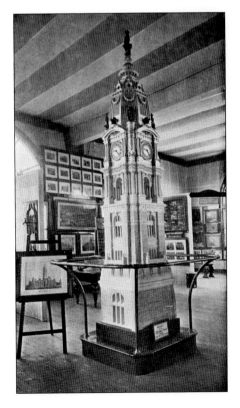

In this view of the Pennsylvania Industrial Educational exhibit, a large model of the Philadelphia Municipal Building is on display beside a photograph of the actual building. Exterior images of the Manufactures and Liberal Arts Building indicate the arched windows seen in this photograph were on the second story of the building.

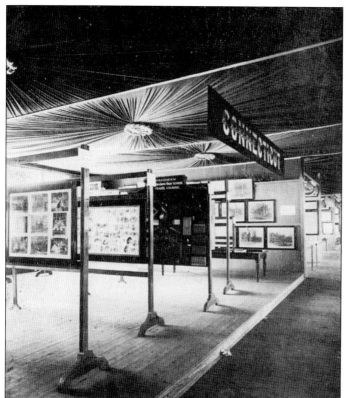

Exhibits of colleges and universities were in the Manufactures and Liberal Arts Building. This photograph shows the corridor containing the Connecticut display of its schools of higher learning. Photographs and information were displayed about Yale University, Wesleyan University, and Trinity College. This image is from the *Connecticut Quarterly* of October-November-December 1896.

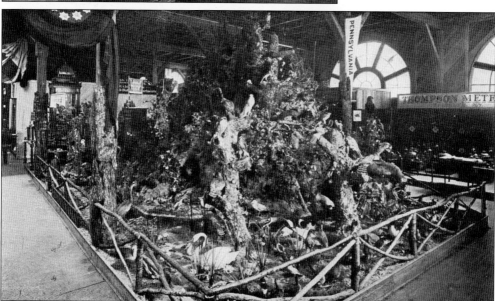

The second story of the Manufactures and Liberal Arts Building also held Pennsylvania's collection of birds and mammals. One thousand animals and their habitats were preserved in a natural landscape through taxidermy. Some of the animals represented were seagulls, turkeys, geese, hummingbirds, buzzards, crows, ducks, rattlesnakes, copperheads, 10-foot blacksnakes, 6-inch garter snakes, frogs, turtles, bears, deer, panthers, otters, and eagles.

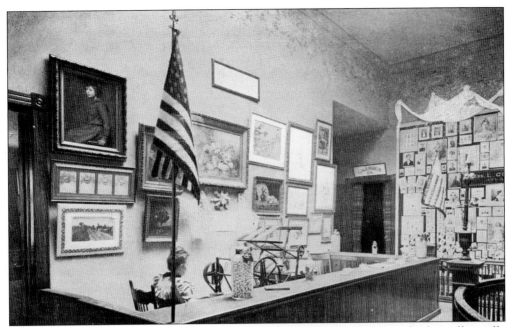

The Woman's Building's exhibits displayed the accomplishments of women, both intellectually and practically. This exhibit showed silk cocoons in every stage of development and women performing the entire process of silk manufacturing. The woman seated in the exhibit is winding silk threads on wheels. A jar of cocoons is on the counter.

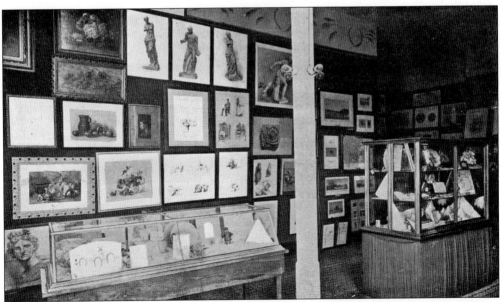

Shown here is a typical exhibit of art created by women inside the Woman's Building. The building also displayed books, embroidery, wrinkle treatments, and agricultural products such as canned fruits, palmetto baskets, and candy. Speakers from around the country gave daily lectures on women's suffrage, education, religion, health, and legal reform issues in the assembly hall of the building. The assembly hall could seat 500, and its walls were painted red.

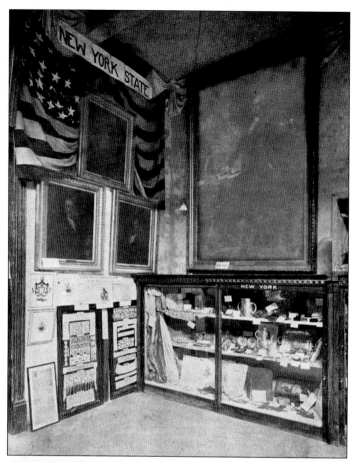

Colonial Hall, a fireproof room on the ground floor of the Woman's Building, housed American Colonial relics. Women from all over the country procured interesting Colonial relics such as a lantern and a silver mug George Washington used at Valley Forge, the pistol that killed Native American leader Tecumseh, pilgrim William Bradford's coffee and tea urn, an inkstand from the signing of the Declaration of Independence, and a pitcher used by pilgrims at old Plymouth. The women displayed a collection of what they termed "Indian Curiosities" in an annex to the Woman's Building. It contained arrows, cooking utensils, and a shirt made out of human scalps.

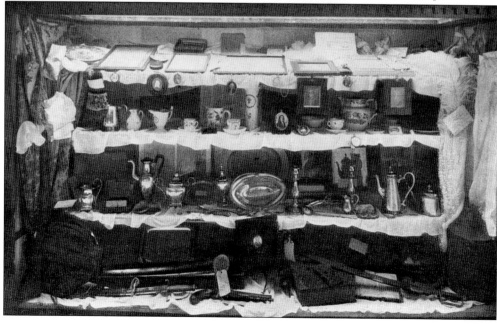

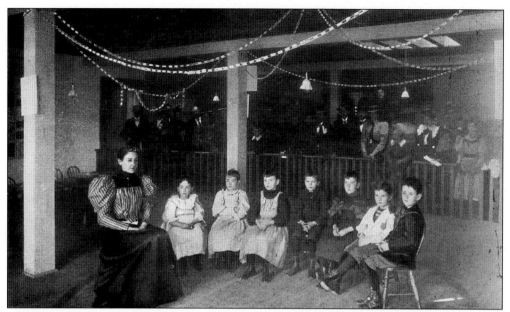

Along with an emergency hospital and a baby nursery, the basement of the Woman's Building hosted a school for deaf children. School founder and teacher Mary S. Garrett is shown with some of her actual students. She taught them to read lips and to speak from an early age. Fair visitors questioned the children, who read their lips and answered the questions perfectly.

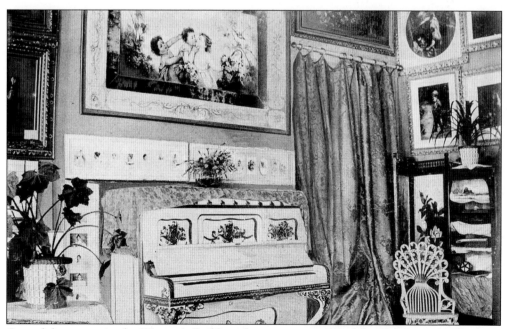

One of the rooms in the Woman's Building that was most praised for its beauty was the Lucy Cobb Institute room. The institute was an elite school in Athens, Georgia, for young ladies. The governor's wife, Susan Atkinson, had attended the school. Fair visitors particularly liked the paintings in this room.

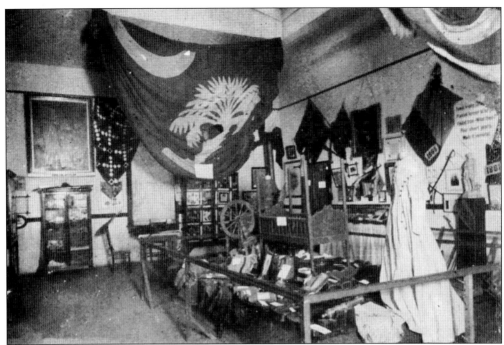

Confederate Hall contained more than 500 Southern relics from the Civil War. Both images on this page show the exhibit with Confederate president Jefferson Davis's cradle in the middle. Some items on display were uniforms, orders, photographs, swords (including Gen. Thomas "Stonewall" Jackson's), a letter Jackson wrote on the battlefield, a sock Gen. Robert E. Lee's wife, Mary Anna Randolph Custis Lee, was knitting when news of the South's surrender reached her, and a lock of black hair from John Wilkes Booth. The tattered American flag hanging from the ceiling in the image above was a captured flag. Although there had been some initial concern, visitors from both the North and South viewed the exhibit with respect.

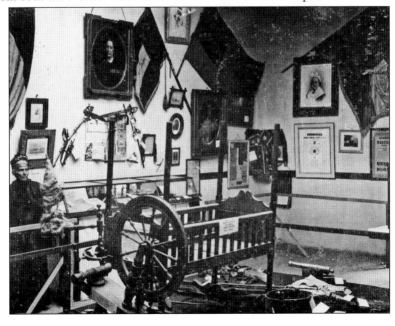

A tightrope walker named Jean Weitzman delighted the exposition crowds weekly. He walked over Lake Clara Meer from the Japanese Village to the tower of the Electricity Building. Halfway across, he stopped and stood on his head. In October, he fell 50 feet headfirst into the lake in front of 12,000 people who mistakenly applauded. This drawing appeared in the *Atlanta Journal* on September 30, 1895.

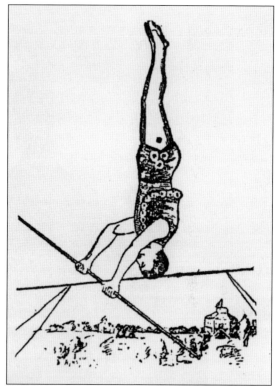

The Westinghouse Electric and Manufacturing Company's exhibit was located inside the Electricity Building and covered almost 2,000 square feet. Part of the exhibit contained an elegant office. Westinghouse's display showed the fair attendees how an electric streetcar worked. General Electric exhibited in the center of the Electricity Building. Southern Bell had a working exhibit in the building; it handled the exposition's telephone system.

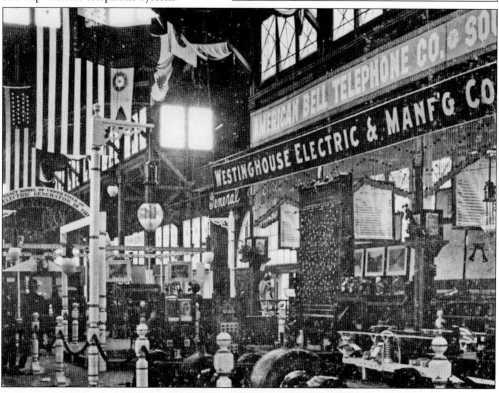

DAYTON BICYCLES.

IT MAKES NO DIFFERENCE

whether you are interested as a dealer in wheels, as a rider or as an intending purchaser — in fact, if you are not especially interested you will make a mistake if you fail to visit the exhibit of DAYTON BICYCLES. Section II.—Columns 5 to 26—Transportation Building.

IF YOU MISS IT, WRITE FOR CATALOGUE.

The Transportation Building contained the greatest number of exhibits at the fair. There were displays of carriages, wagons, farm implements, trains, streetcars, toboggans, balloons, baby carriages, hearses, boats, hand trucks, steamships, and buggies. Bicycle manufacturers were extremely competitive and had the most displays in the building. The building contained overflow from other parts of the exposition, such as an information booth and a Chilean fertilizer exhibit.

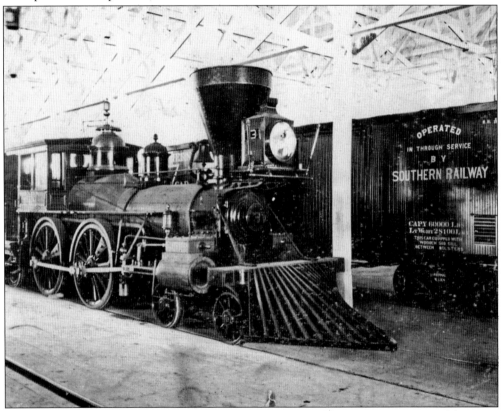

More trains were exhibited in the Train Shed, located south of the Transportation Building near Midway Heights. Inside were six Pullman luxury cars, sleeper cars from various manufacturers, a dozen locomotives of the latest design, and ancient locomotives for educational purposes. The *General* locomotive, captured by the infamous Andrews's Raiders during the Civil War, was exhibited, as shown here.

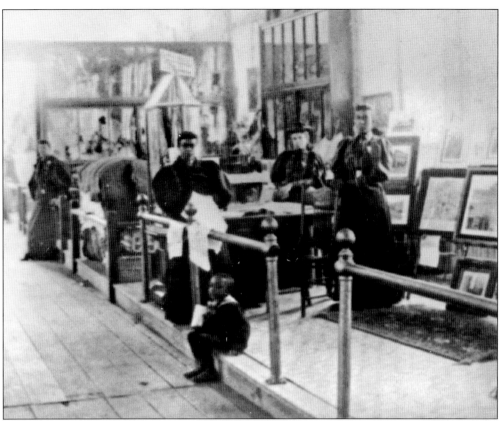

Exhibits such as these in the Negro Building displayed African American inventions, art, religion, education, banking, agriculture, embroidery, music, literature, tile work, cabinetry, upholstery, wood working, food, photographs, and farm work. The chief of the Negro Department, Irvine Garland Penn, spoke on the building's opening day, accompanied by musical selections from Morris Brown, Spellman, and Atlanta University students. Penn said the African Americans' "material progress faces the visitor, from whatever clime he may hail, and ought to serve as an argument in his favor for years to come." In addition to the exposition itself, African American ministers, doctors, lawyers, bankers, business leaders, missionaries, and educators converged upon Atlanta to meet and explore their futures.

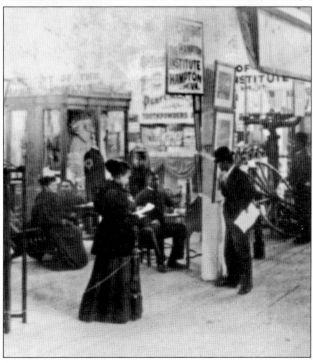

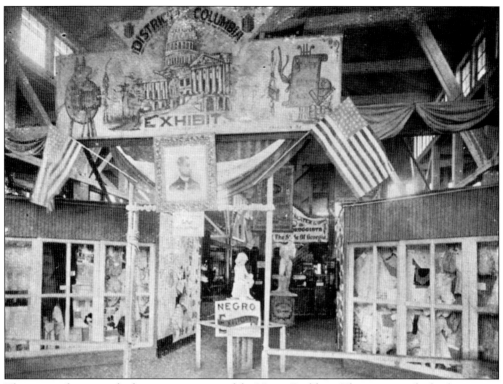

This image shows inside the main entrance of the Negro Building. The statue in the back center is of an African American man with his wrists bound in chains that are nearly severed, illustrating the motto under it: "Chains broken, but not off." The statue was created by artist A. C. Hill.

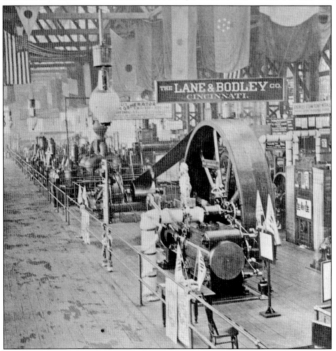

Machinery Hall contained a labyrinth of engines that ran the fairgrounds. Noise from the machines was deafening to exposition visitors, but they came to the building regardless to witness the exhibition of technology. Machinery Hall backed up to Midway Heights, and its Crystal Cave attraction was underneath the building. The cave had 200,000 pounds of crystals on its walls. (Courtesy of Georgia Archives, Vanishing Georgia Collection, Image No. 667.)

Besides housing the machines that ran the Atlanta Exposition lights and fountains, Machinery Hall contained exhibits of machines for making items such as clothing, rope, carpet, paper, clocks, buttons, jewelry, wire, pins, saws, and exposition souvenirs. There were machines for making coffee, cigarettes, and soap. This advertisement was in the daily program that was distributed throughout the fairgrounds.

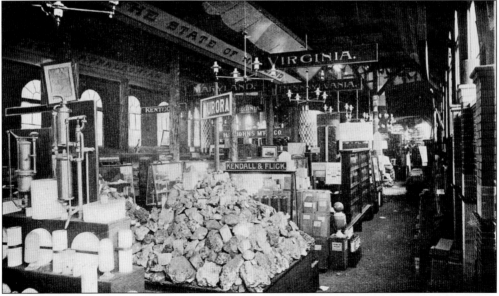

Resources from all the states, but particularly the Cotton States, were displayed in the Minerals and Forestry Building. The building contained exhibits such as a timber testing machine, 24 polished columns of Southern woods, the largest block of coal ever taken from a coal mine, a pillar of salt from Louisiana, lead ore, iron ore, gold ore, valuable Southern gems, geological maps, and Southern flora.

The Minerals and Forestry Building was divided into three sections: Argentina, Minerals, and Forestry. This photograph shows the U.S. Department of Agriculture's display of Southern timbers. Resin window panes and cushions stuffed with moss were on display. Thomas Jefferson's baby cradle—"the cradle of democracy"—was placed in the center of the building, apparently because it was made of wood.

Located on Peachtree Street at Ellis Street, the Hotel Aragon was the most prestigious hotel in Atlanta. Pres. Grover Cleveland stayed there when he visited the exposition. The hotel's restaurant atop the Minerals and Forestry Building could seat 1,000 people at a time. Fair visitors were served drinks, oysters, salads, sandwiches, steaks, chops, ice cream, and ices while listening to a Mexican orchestra and viewing the entire fairgrounds.

The largest exhibits in the Agricultural Building were of beer and whiskey. Pretty girls offered free samples of every Southern food imaginable throughout the building, the most popular of which were red kidney beans. Exhibit booths were often made of the foods on display, such as cornstalks or coconuts. A house in the center of the building was made of the bottoms of 3,000 multicolored liquor bottles.

In this stereoview photograph, entitled "Blooded Stock," the herd of prized Holsteins owned by William Benninger of Walnutport, Pennsylvania, can be seen. The cows are described as "blooded" because they were of pedigree stock. One of Benninger's bulls at the exposition, Sir Jewel, weighed 2,580 pounds. Other farm animals, such as pigs and poultry, were exhibited at the exposition as well.

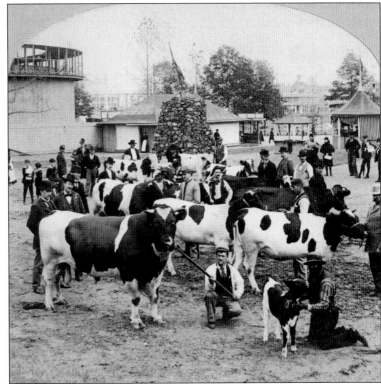

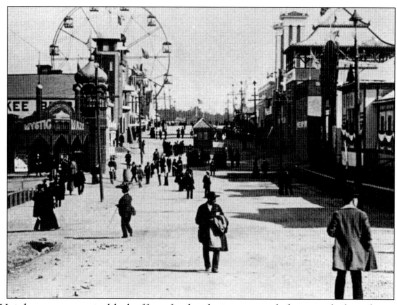

Midway Heights was a veritable buffet of ridiculousness, and the people loved it. The list of attractions is immense: Shooting the Chutes, Palace of Illusions, Old Plantation, Camera Obscura, Haunted Swing, Mystic Maze, Phoenix Wheel, Merry-Go-Round, Vaudeville Theatre or Trocadero, Beauty Show, Streets of Cairo, Amazon Warriors, Living Pictures or Phantoscope, Moorish Palace, Little World, Miniature Model of Chicago Fair, Gold Mine, Crystal Cave, Deep Sea Diving, Water Closets, Peep Show, Ice Grotto, Parisian Theatre, Scenic Railway, Hagenbeck's Trained Animals, Rocky Mountain Ponies, Monkey Paradise, Ostrich Farm, Chinese Village, Japanese Village, German Village, Dahomey African Village, American Indian Village, Mexican Village, Punch and Judy, Electric Theatre, and Chinese Theatre. There were countless fortune-tellers, gypsy dancers, photography studios, souvenir booths, restaurants, food stands, and bars. The two images here show how the crowds fluctuated, particularly during September and October.

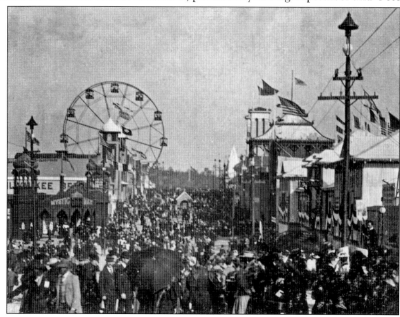

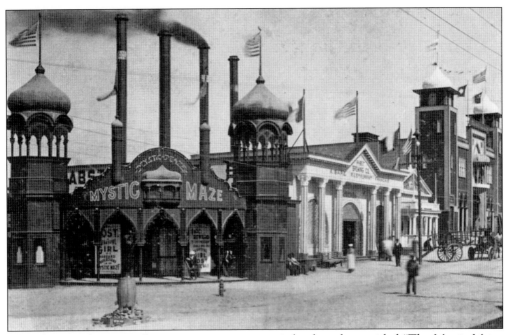

This photograph appeared in an exposition souvenir book and was titled "The Mystic Maze, Electric Theatre and Moorish Palace-Midway." The Mystic Maze was a building of corridors, mirrors, and seemingly endless halls. Hundreds of wax figures were inside the Moorish Palace. Henry Grady, Pope Leo XIII, Martin Luther, and Romeo and Juliet all appeared at the Moorish Palace in wax.

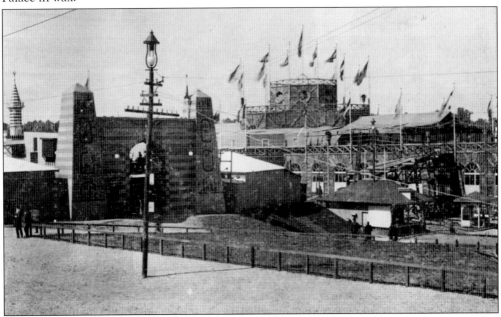

The Streets of Cairo was one of the most popular villages on the Midway. To the left in the photograph is the imposing front entrance of this fantasy version of the Egyptian city. A restaurant inside, named the Cairo Garden, was known for good sandwiches and beer. In the background is the Minerals and Forestry Building.

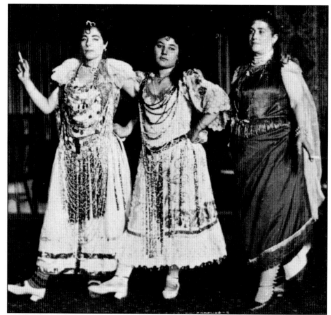

Inside the Streets of Cairo fair visitors found booths, bazaars, camels, dancing bears, monkeys, and the most scandalous part of the entire Atlanta Exposition: the Coochee-Coochee dancers, seen above performing at the Egyptian Theatre. One *Leslie's Weekly* writer remarked that this was where "half-bred Egyptians, Levantines, French Algerians, Tunisians, and alleged Turks perform the *dance du ventre* and other muscular but reprehensible feats." The October 25, 1895, *Atlanta Journal* told the story of a bill that was introduced in the state legislature to outlaw the Coochee-Coochee dancers. One representative defended the dancers and said that "if a man wanted to go to the devil by the Coochee-Coochee dance route, it was none of the legislature's business." The bill passed. Many members of the state legislature felt the need to see the dance before the bill went into effect.

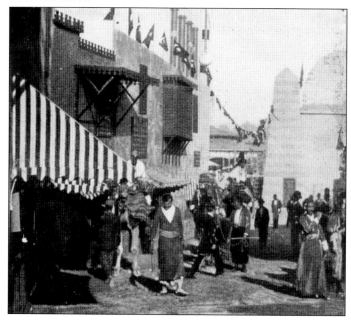

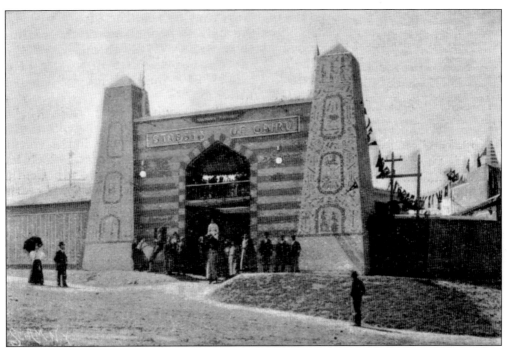

Appearing in the November 16, 1895, edition of *Scientific American*, this photograph shows a group of the Streets of Cairo's inhabitants crowded around the front entrance and a couple of fair visitors gazing upon the odd-looking crowd. The Victorian fairgoers were captivated by the Middle Eastern part of the Midway.

German Carl Hagenbeck is known today as the father of modern zoos. In the late 19th century, he captured wild animals and advocated keeping them in a natural setting instead of cages. Hagenbeck supplied zoos and circuses, and traveled the world with an animal show. A three-year-old girl brought baby lions into the audience at the Atlanta Exposition, and the trained elephants seen here reportedly acted humanlike.

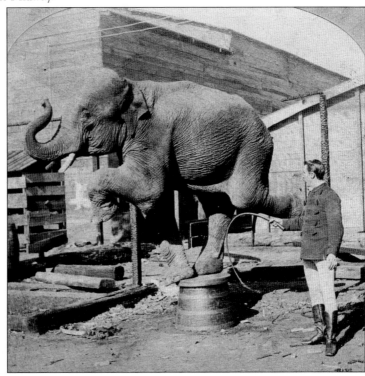

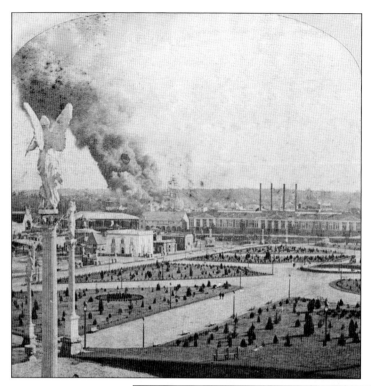

This stereoview photograph is called "Hagenbeck's Building on Fire." In October, a stove in the Old Plantation attraction exploded, causing major damage to Hagenbeck's building and the Living Pictures exhibit. Hagenbeck rebuilt immediately. The Phantoscope in the Living Pictures attraction was the world's first movie projector. Its inventors closed the attraction and sold the Phantoscope to Thomas Edison, who made a success out it with his modified version: the Vitascope.

Named the "Coming Woman," this stereoview photograph shows two women who were meant to parody the Victorian era's ideal modern woman, referred to as the "New Woman." They appeared in the beauty show on the Midway and were considered highly unattractive and shocking because of their pants. Across the lake, the lectures in the Woman's Building continued to educate the ladies on how to become a New Woman.

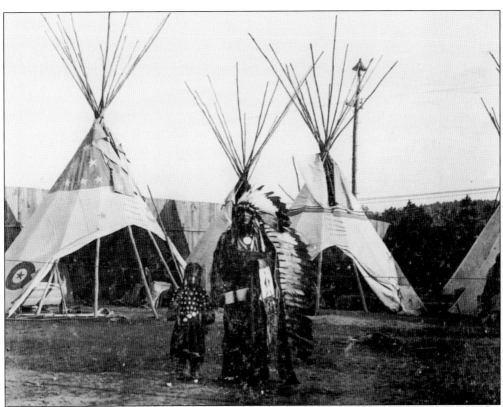

Sioux Indians were displayed on the Midway with authentic teepees, allegedly for historic and anthropological education. The chief on the right, named Stand-and-Look-Back, had fought against Brig. Gen. George Custer. Stand-and-Look-Back's wife had a baby during the fair, and having great respect for the chief of the Atlanta Exposition, he named the baby "Collier-Stand-and-Look-Back."

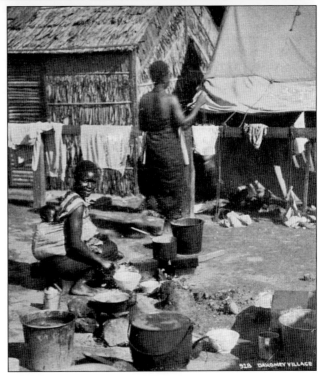

In the October 10, 1895, edition of *Leslie's Weekly*, it was written that the Dahomey African Village at Midway Heights was "where savage Africa confronts savage America in equal ingenuity and dirt." Seeing conditions such as these that were considered normal in Africa startled the observers and opened their sheltered eyes.

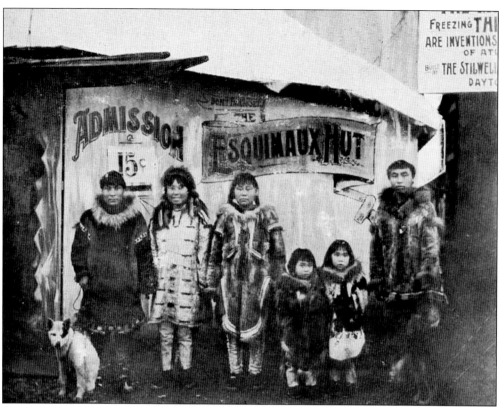

Esquimaux, or Eskimos, stood in front of their hut in the Ice Grotto on the Midway. There was an ice-making machine inside this attraction that made a foot of ice on the ground for skating performances. Visitors watched the skaters through glass. The Ice Grotto was kept at zero degrees Fahrenheit inside.

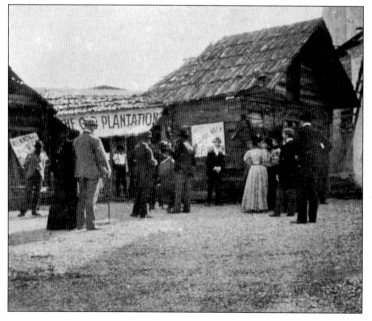

The Old Plantation attraction is seen here as it appeared at Midway Heights during the exposition. It was blatantly racist and glorified the days of American slavery. While the attraction was touted as amusing with cakewalks and minstrel shows, it nonetheless must have seemed disrespectful to African American fair attendees.

Titled "Pickaninnies of the Old Plantation Cabin," this photograph appeared in the December 5, 1895, *Leslie's Weekly*. Painful to read today, an *Atlanta Journal* writer described the attraction as "the fun of history, the sport of character, the humor of race, the music of a nation, the most unique piece of our great American history plucked up from the past and placed down before us compact and complete."

Everything from Mexico existed in the Mexican Village with one exception: bull fights. The exposition directors had decreed there would be no bullfighting because it was cruel to the bulls and frightened the horses. Therefore, the Mexicans, no doubt with some American help, built a real bullfighting arena outside the exposition grounds on Wilson Avenue, now Fourteenth Street. Their plan was thwarted, however, and no bull blood was shed.

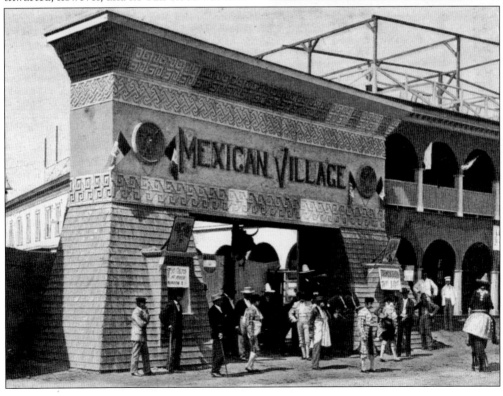

A clown sits in a cart with a trained horse leaning over his head in this photograph from the Mexican Village, along with a man in traditional Mexican clothing and a couple in formal wear. This group most likely performed in one of the daily shows in the Mexican Village arena. The Agricultural Building towers above the performers to the north.

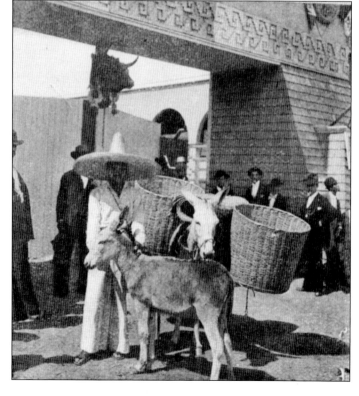

Two Mexican donkeys appear in this photograph from the October 24, 1895, edition of *Leslie's Weekly*. Donkeys wearing baskets on both sides amused the fair visitors because when the donkeys were tired, they leaned their heads against a basket and took a nap standing up. Mexican hats, like the one seen here on the donkeys' master, weighed 12 pounds.

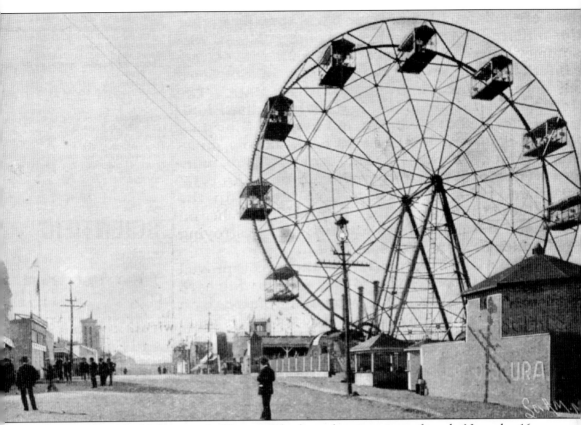

Towering above the Midway was the Phoenix Wheel, seen here in an image from the November 16, 1895, *Scientific American*. It was a smaller version of G. W. G. Ferris's wheel that had appeared at the World's Columbian Exposition in Chicago two years before the Atlanta Exposition. The Phoenix Wheel was set upon the highest part of the fairgrounds, 75 feet above Lake Clara Meer. It was 125 feet in diameter and made of 250,000 pounds of steel, and its axle weighed 10,000 pounds. The Phoenix Wheel took its riders approximately 200 feet above the general level of the exposition, where they could see the exposition grounds and surrounding countryside. It was the first wheel of its kind built in the South. The octagon-shaped building in the right of the photograph was the Camera Obscura attraction. Atop its roof were lenses that showed magnified moving pictures of the grounds and crowds at the exposition.

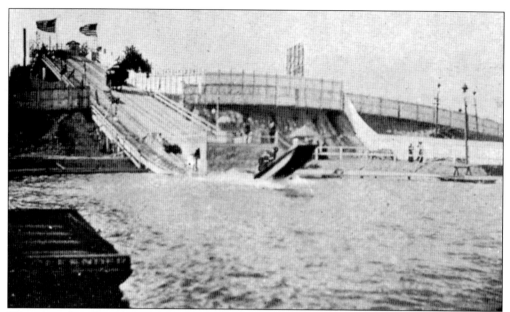

"Have you shot the Chutes?" was an advertising phrase that appeared in the local newspapers throughout the 100 days of the exposition. This attraction was located just north of the intersection of Tenth Street and Argonne Avenue, slightly out of the park grounds. Tickets were 25¢. Riders reported that not one drop of water splashed on them when they shot the chutes, and most named it their favorite exposition amusement. A lady from the Women's Board said to an *Atlanta Journal* reporter, "Ministers and moralists may find objection to women riding a bicycle . . . but when it comes to women shooting the Chutes, they had better keep their hands off!"

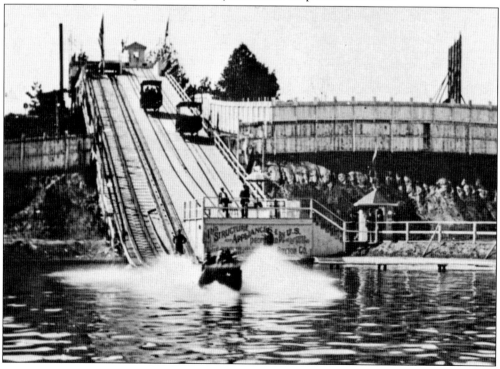

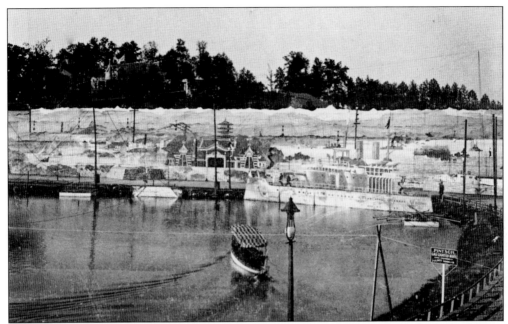

This fake background and ship represented the Chinese fort Wei-Hai-Wei, which was located on the Chinese coast in reality and on the shores of Lake Clara Meer at the Atlanta Exposition. Henry Pain designed a fireworks show that represented the bombardment of the fort during the Sino-Japanese War. It was called "the Storming of Wei-Hai-Wei," and it lasted two hours and included more than 400 people on stage.

The Japanese Village was situated on Lake Clara Meer, northeast of today's Piedmont Park pool. Inside the walls were living quarters, artists' booths, a teahouse, a theater, and a tiny lake filled with goldfish. Japanese acrobats performed in the theater. This attraction was known for providing a peaceful repast at the Atlanta Exposition.

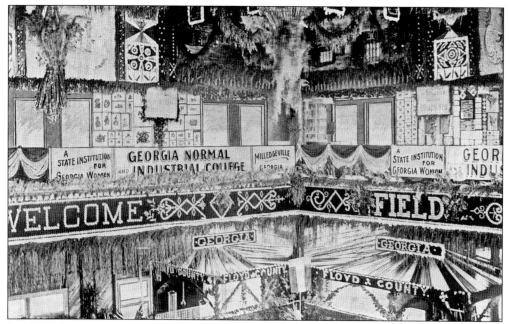

Inside the Georgia State Building was a cornucopia of the state's offerings to the world. Georgia displayed its agricultural wares along with its mineral resources and educational institutions. A special train track was put in the northern end of the fairgrounds to get the largest cube of marble ever quarried in Georgia into the building.

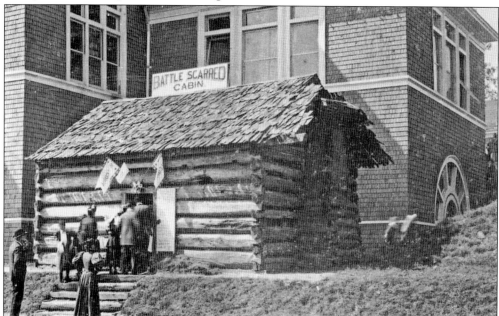

Outside the Georgia State Building was the Battle Scarred Cabin. The cabin was previously located in Kennesaw, Georgia, and had withstood a Civil War battle. Bullets and cannonballs had put 40 holes through solid wood logs, and the family that owned the cabin came back after the war, patched up the holes, and lived there for years. The cabin was brought to the exposition to display the battle scars.

Four

Relics and Ruins

Approximately 1 million people visited the Atlanta Cotton States and International Exposition of 1895, and most of them brought a little something home with them to remember the fair. Many of these relics have survived, along with the stone ruins of urns and staircases in the park, to allow the modern world to physically touch a piece of the fair. The image here is from the exposition's official program.

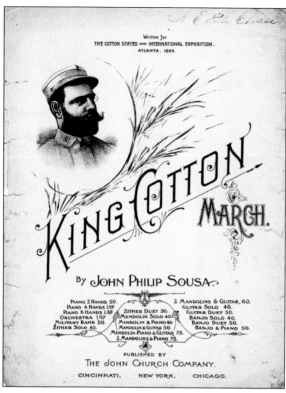

Live music was an important part of the exposition to its attendees. Throughout the day and evening, bands and orchestras accompanied the visitors as they strolled the fairgrounds. Two sheet music covers are shown here. John Philip Sousa, known for his military and patriotic marches, composed the official march of the exposition: "King Cotton." The march was played frequently throughout the fair and particularly during the many military reviews. Some of the lyrics of "The Southern Beauty Waltz" are as follows: "I sing to you Southern Beauty! Always so true to duty! With ev'ry sweet charm laden, your fame shall live so long. Pure as the stars above you, ev'ry true heart should love you." Another famous conductor and band, Victor Herbert and Gilmore's Band, played daily from the two outdoor bandstands during the first month of the fair.

The Atlanta Exposition had its own printing press, and it handed out a daily catalogue, called the "Official Programme," to the fairgoers. It contained advertisements from private exhibitioners, restaurants, and hotels, and more importantly, it contained information about the concerts, lectures, shows, and official days of the exposition. Additionally, the program notified the visitors where they could find the hospital, baby nursery, and post offices at the exposition. The image above is from the November 30, 1895, edition of *Harper's Weekly*, and the drawing was called "the Catalogue Boys" after the lads that handed out the catalogue. The photograph below is of an actual catalogue.

Pictured here is the official souvenir medal of the Atlanta Exposition featuring the mascot of the New South, Henry W. Grady. The medal was stamped on site at a mint in the U.S. Government Building and was made of oreide, an alloy of cooper, tin, and zinc. On the back is stamped a design comprised of a bale of cotton, a phoenix, and hands holding an olive branch.

GIVE A SOUVENIR SPOON.

To your girl to keep fresh in her memory the happy days at the exposition. Or perhaps you need a ring? A. F. Pickert has them. Beauties, too, and you should not leave Atlanta without selecting one. His whole stock is worth a thorough inspection and you can pick out from it some piece of Jewelry or silverware to delight your friends as a token from the south. The price will make but a small hole in your pocketbook.

A. F. PICKERT,
51 Whitehall street.

Small souvenir spoons were as popular in 1895 as they are today. Some of the fair's spoons showed exposition buildings in the bowl. The official souvenir spoon featured a cotton boll inside the spoon bowl, and it was sold by Maier and Berkele Jewelers at the exposition and at the jeweler's store in downtown Atlanta.

Badges and medals were all the rage at the exposition, and the fair attendees wore them to show their allegiance to an organization, to indicate being a member of a certain committee, and to celebrate official days at the fair. The image to the right is a photograph from 1896 displaying some of the badges associated with Pennsylvania, which are as follows: Liberty Bell Escort (top left), Pennsylvania Commission (top right), Women's Auxiliary Commission (center), Pennsylvania Day (bottom left), and Liberty Bell Day (bottom right). Badges also served to identify the 12,000 children who were allowed to receive free streetcar transport to the fair on Liberty Bell Day; their teachers had distributed them at school the preceding day. The photograph below is of a Liberty Bell souvenir badge that is still intact.

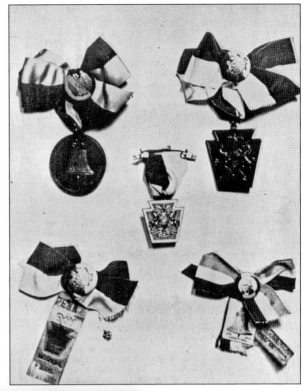

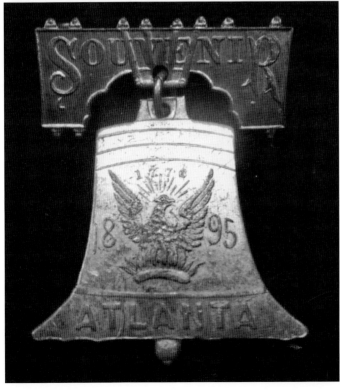

Souvenirs made of ruby stained glass or ruby flash glass were widespread at the end of the 19th century and early 20th century. It was common to have the date, place, and even a name etched on the glass. This cup was most likely etched on site at the exposition. "Miss Willie Lessly" is etched on the other side of the cup.

The metal box shown here was meant to be either a matchbox or a toothpick box. It was rather coarsely etched, probably on site at the Atlanta Exposition. Tin and pewter souvenirs such as cups, plates, and small boxes with hinged lids like this one were common in the late 19th century.

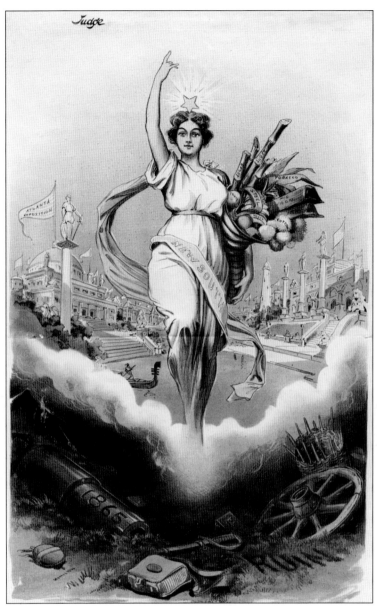

Judge, a humorous weekly magazine in the late 19th century, first distributed this cartoon in its special edition dedicated to the South in the fall of 1895; it reappeared in later editions. The drawing was heavy with symbolism. The woman, representing the New South, stands upon the Old South, with the Atlanta Exposition glowing behind her. The Old South is symbolized by the word "Ruin" burned upon the grass amid war paraphernalia. The New South woman holds fruit, sugar, cotton, tobacco, steel, and pig iron in a cornucopia showing the South's arrival to an industrially and agriculturally regenerated economy. Times had changed, and cotton was no longer king in the South. Underneath the drawing appears a poem called "From Darkness to Light," dedicated to the Atlanta Exposition. "Hail, splendid South! from out the ruins rising, / In morning's glory from the night of war. / Courage survives. all rancors past despising, / And Wounds received in honor leave no scar. / The New South, that was Grady's fair ideal, / Stands now, through enterprise and genius, real."

Nine years after the exposition, the City of Atlanta bought the fairgrounds for $99,000 to use as a city park. Marked "Piedmont Park," this photograph shows two ladies in a boat on Lake Clara Meer about the time that the city acquired the park. Trees had grown in around the lake, and it appears much like it does today.

Victorian trade cards were popular between 1880 and 1900. Companies handed them out for free because the cards were a convenient advertising method. The New Orleans Coffee Company Pavilion at the Atlanta Exposition served Morning Joy coffee in elegant china. For years afterward, companies bragged of their gold medals at this and other expositions.

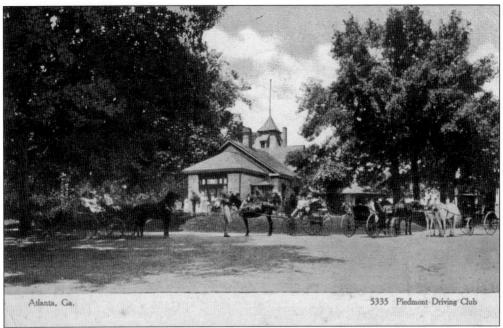

Horses are lined up for driving in this postcard showing the Piedmont Driving Club sometime before 1907. Piedmont Park was originally club grounds designed for driving horses around the area known during exposition days as the Plaza. The card is postmarked from Atlanta on November 10, 1909, and it was published by the C. T. Company Chicago.

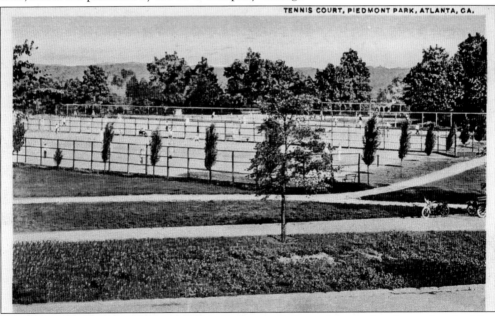

In 1913, clay tennis courts were built in Piedmont Park, and tennis has been played with a vengeance in the park ever since. Published by the I. F. Company of Atlanta, this postcard shows the courts soon after they were built. Notice the early automobile on the right side of the postcard. The park's tennis courts are located in the same spot occupied by the exposition Manufactures and Liberal Arts Building.

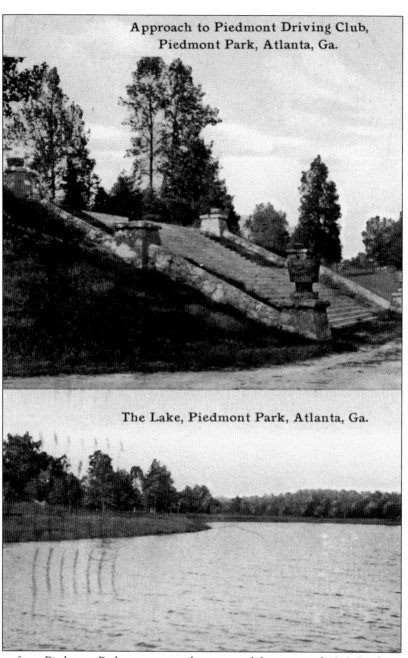

Two scenes from Piedmont Park are seen in this postcard from around 1910. In the top image, the staircase, which still exists today, would have been located between the Auditorium and the Georgia State Building on the west side of the Plaza during the Atlanta Exposition. As indicated on the postcard, the Piedmont Driving Club buildings and grounds are just northwest of the stairs. In the lower image of the postcard, the lake appears to be in a peaceful rural setting without the monstrously sized exposition buildings surrounding it. The card was postmarked from Atlanta on October 12, 1911, and mailed with a 1¢ stamp. It was published by the I. F. Company in Atlanta. A man named Walter sent the postcard to Ethel Brown in Forsyth, Georgia, and he wrote to her, "We are all getting on nicely."

The stairs and urn in the left side of this 2009 photograph are the same ones pictured in the top image on the preceding page. In the background across the Plaza are stairs that once led to the hill where the Fine Arts Building, the Chimes Tower, and the U.S. Government Building were located. The building peeping through the trees on the hill is part of the Atlanta Botanical Garden's facilities.

Three boys and a few ducks enjoy a summer afternoon at Lake Clara Meer in 2009. The children are shown sitting on the dock at the Visitor Center, where the Atlanta Exposition boathouse was located. Today the lake is stocked with largemouth bass, crappie, bream, and, allegedly, 30-pound catfish for local fishermen.

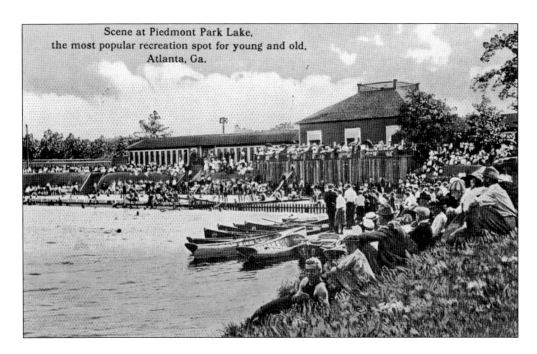

Swimming at Piedmont Park has been a summer pastime in Atlanta for generations. The above image is a card postmarked on March 30, 1917. The message on the back of the postcard is poignant: "Head, heart and hands have been full this week. . . . Soldier boys came home Tuesday." In the above postcard, a wooden bathhouse that was built in 1911 can be seen. Its replacement, a granite structure, was built in 1927. The granite structure has been renovated and is now used as a special events facility. The photograph below shows the same view in 2009 with a new pool and the newly renovated bathhouse.

Atlanta's favorite ice-skating rink was frozen Lake Clara Meer until the mid-1950s. In this 1940 photograph, Dr. George W. Bohne poses at Piedmont Park in the middle of the lake. Bohne was an optometrist in Atlanta for 37 years, beginning his practice within the Kay Jewelry Store at 3 Peachtree Street. Lake Clara Meer's name has two possible origins. The first, and more commonly accepted, origin is that the name means "clear lake" in German, Dutch, or Old English. The other possible origin of the name is thought to be a girl named Clara Fritz, daughter of Johann Fritz, who owned land near the park when the lake and exposition grounds were being constructed. Atlanta Exposition architect and landscape designer Grant Wilkins conducted business with Johann Fritz, who gave up pasture land for the Atlanta Exposition. (Courtesy of Linda C. Bohne.)

Midtown Atlanta's 2009 skyline towers above Piedmont Park's Active Oval, where baseball, volleyball, and running are daily activities for hundreds of today's local residents. This open field was the Atlanta Exposition's Plaza, and the landscape remains virtually unchanged from the days when Victorian exposition visitors sauntered its bucolic walkways. Once an antebellum cornfield, the central grounds have changed in function along with the city's progress. From horse and carriage driving to 21st century sports, the field has invited Atlantans to traverse its level floor. The viewpoint in the above photograph is from the north hill looking south toward the lake, and the viewpoint below is from the east looking toward the west. (Below, courtesy of Laura Lancaster Archer.)

Part of the northern end of Piedmont Park has been leased to the Atlanta Botanical Garden, whose gates can be seen in this 2009 photograph at the top of the stairs. This staircase led to the exposition's U.S. Government Building. The Atlanta Botanical Garden is one of the city's treasures with its gardens and activities such as the Children's Garden, Cocktails in the Garden, telephone gardening help line, and outdoor art exhibits.

Lake Clara Meer shimmers behind Charlotte Barkett Robinson (1966–2008) at a Susan G. Komen Breast Cancer Foundation event in 2006. Many worthwhile events—for recreation, entertainment, and philanthropy—take place in Atlanta's Piedmont Park. Finish lines for the Peachtree Road Race, Aids Walk Atlanta, and the Breast Cancer 3-Day are in the park. (Courtesy of Bill Robinson.)

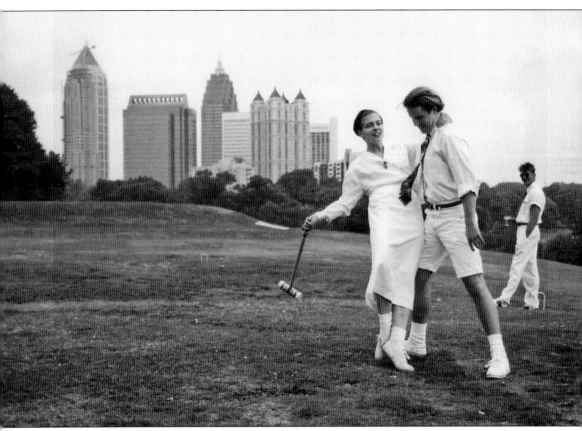

Carolyn McLaughlin and two unidentified men play croquet in Piedmont Park in this 1989 photograph. Since its inception, the park has been the setting of innumerable little scenes like these, as well as the arena for gargantuan gatherings of several hundred thousand people. Piedmont Park is to Atlantans what Central Park is to New Yorkers: a protected, urban green spot that is uniquely integrated within the city. Festivals held in the park—Dogwood, Arts, Jazz, and Pride—have influenced the fabric of modern-day Atlanta. The park has undergone improvements, renovations, and restorations, the greatest of which have occurred in the past 20 years because of the efforts of the Piedmont Park Conservancy, a nonprofit group that oversees the park with occasional controversy but magnificent results. Three million visitors tread upon the grounds of the park each year, and the majority has only a vague idea of what happened here in 1895. The Cotton States and International Exposition, commonly known as the Atlanta Exposition, left the legacy of Piedmont Park to Atlanta. (Courtesy of Jeffrey Keesee.)

BIBLIOGRAPHY

Atlanta Journal, September 18, 1895–December 31, 1895.

Bacon, Alice M. *The Negro and the Atlanta Exposition*. Baltimore: Trustees of the John F. Slater Fund, 1896.

Cooper, Walter G. *The Cotton States and International Exposition and South, Illustrated*. Atlanta: The Illustrator Company, 1896.

Harvey, Bruce, and Lynn Watson-Powers. "The Eyes of the World are Upon Us: A Look at the Cotton States and International Exposition of 1895." *Atlanta History* 39 (Fall-Winter 1995): 5–11.

Mason, Herman "Skip" Jr. *Going Against the Wind: A Pictorial History of African-Americans in Atlanta*. Atlanta: Longstreet Press, 1992.

New York at the Cotton States and International Exposition Held at Atlanta, GA 1895. Albany, NY: Wynkoop Hallenbeck Crawford Company, 1896.

Pennsylvania at the Cotton States and International Exposition Atlanta, Georgia, September 18th to December 31st, 1895. Pennsylvania: Clarence M. Busch State Printer, 1897.

Roth, Darlene, and Jeff Kemph. *Piedmont Park: Celebrating Atlanta's Common Ground*. Athens: Hill Street Press, 2004.

Rydell, Robert A. *All the World's a Fair: Visions of Empire at American International Expositions, 1876–1916*. Chicago: The University of Chicago Press, 1984.

Washington, Booker T. *Up from Slavery*. Cambridge, MA: The Riverside Press, 1901.

Yearbook of the United States Department of Agriculture: 1895. Washington, D.C.: Government Printing Office, 1896.

www.arcadiapublishing.com

Discover books about the town where you grew up, the cities where your friends and families live, the town where your parents met, or even that retirement spot you've been dreaming about. Our Web site provides history lovers with exclusive deals, advanced notification about new titles, e-mail alerts of author events, and much more.

Arcadia Publishing, the leading local history publisher in the United States, is committed to making history accessible and meaningful through publishing books that celebrate and preserve the heritage of America's people and places. Consistent with our mission to preserve history on a local level, this book was printed in South Carolina on American-made paper and manufactured entirely in the United States.

This book carries the accredited Forest Stewardship Council (FSC) label and is printed on 100 percent FSC-certified paper. Products carrying the FSC label are independently certified to assure consumers that they come from forests that are managed to meet the social, economic, and ecological needs of present and future generations.

Mixed Sources
Product group from well-managed forests and other controlled sources

Cert no. SW-COC-001530
www.fsc.org
© 1996 Forest Stewardship Council

Find Your Place in History.